IMAGES
of America

JEANNETTE

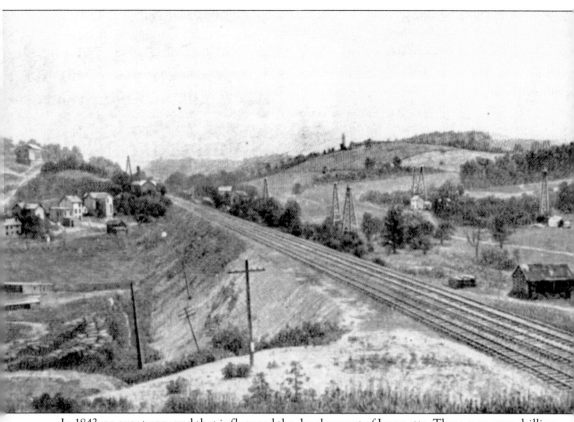

In 1843, an event occurred that influenced the development of Jeannette. Three men were drilling for salt along a creek, now called Brush Creek, situated below Grapeville station. At a depth of 300 feet, when a disagreeable odor was noticed coming from the well, the men did not know at the time that they had struck natural gas. About 50 years later, new progress was made in drilling equipment, and the area around Jeannette was soon dotted with gas wells.

IMAGES
of America

JEANNETTE

Terry Perich and John Howard

ARCADIA
PUBLISHING

Published by Arcadia Publishing
Charleston, South Carolina

Printed in the United States of America

Library of Congress Catalog Card Number: 2005924672

For all general information contact Arcadia Publishing at:
Telephone 843-853-2070
Fax 843-853-0044
E-mail sales@arcadiapublishing.com
For customer service and orders:
Toll-Free 1-888-313-2665

Visit us on the Internet at www.arcadiapublishing.com

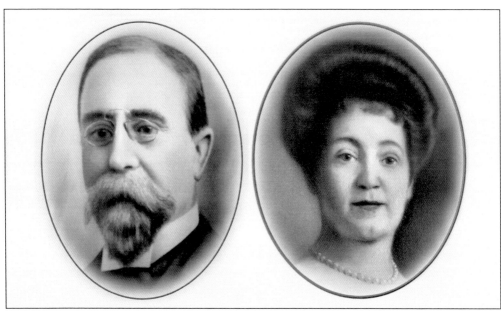

H. Sellers McKee, the founder of Jeannette, was born on March 5, 1843, and died on June 10, 1924. The town was named in honor of his wife, Jeannette Hartupee McKee, who was born on May 18, 1849, and died on November 13, 1924.

CONTENTS

ACKNOWLEDGMENTS

We would like to acknowledge and extend thanks to the following: the Jeannette Area Historical Society, the Jeannette American Legion Post 344, the Jeannette Public Library, the *Greensburg Daily Tribune*, the *Jeannette News Dispatch*, and the *Jeannette News*. The majority of the images contained in this book are postcards and original photographs from the collections of Terry Perich and David Kasparek. We would also like to thank Kathy Perich and Cindy Howard for proofreading and offering suggestions. Their support and encouragement helped make this book possible. We also extend our thanks to Amy Englehart for providing us with the cover photograph. Information about that image may be found on page 24.

INTRODUCTION

Up until 1762, Jeannette's land was part of a vast wooded wilderness that included all the territory west of the Allegheny Mountains, which the French called "impassible" and the English "endless." Shawnees, Delawares, and other American Indians doubtless hunted along Brush Creek from time to time. Of all the historic sites found in this county, that of the Battle of Bushy Run, about two miles north of Jeannette, is best known. Westmoreland County has never played a more important part in the history of the United States than at the Battle of Bushy Run, which marked the end of Pontiac's War, saved the western front, and brought the tribes of American Indians to submission—results that can hardly be overestimated.

H. Sellers McKee, in company with the Western Land and Improvement Company of Philadelphia, collaborated with James Chambers and David Z. Brickell of Pittsburgh to establish a factory in the area, and in December 1888, ground was broken for the first glass plant. Jeannette was plotted in April 1888, and by April 1889, four thousand people called Jeannette home. The town was named in honor of H. Sellers McKee's wife, Jeannette.

"The Glass City" was the first large manufacturing town within Westmoreland County. It had the largest window-glass plant in the world and the largest pressed-glass factory in the country. Jeannette produced more glass in various forms than any other place in the United States. At noon on Monday, May 20, 1889, the first glass was blown in Jeannette, and since that date the city and its manufactories have sent their glass products all over the world. Along with the rubber plant, Jeannette's seven great glass factories provided the city's business life. The largest tableware-glass factory in the world was that of McKee-Jeannette Glass Works. This was the pioneer plant in Jeannette and was then known as McKee Brothers' Works. The American Window Glass Company had the largest single window-glass plant in the world; it was formerly the Chambers-McKee Glass Company.

When Oakford Park opened in 1896, it was little more than a place for picnics. There were benches, rustic bridges, and tree-lined pathways throughout the park. Lake Placid, as the man-made lake was named, soon became the focal point for many visitors. Rowboats were available for rent. As time passed, more structures began to dot the landscape below and around the lake. Vaudeville acts, opera singers, poets, and thespian companies came to the Oakford Theatre at the park. On weekends, the most-popular bands of the era played for the dancers' pleasure.

The morning of Sunday, July 5, 1903, began just as July 4 had ended—overcast, hot, and humid. But before day's end, tragedy would strike Oakford Park. On Monday, July 6, 1903, the *Greensburg Daily Tribune* published the following two headlines: "TERRIBLE RAIN STORM CAUSES DEATH AND DESTRUCTION" and "DAM BURSTED AT OAKFORD PARK—WATER DOES MUCH DESTRUCTION." A majority of the people who were killed or injured had taken

shelter in the park's waiting rooms and a trolley car. When the surging flood waters swept through, the trolley car was derailed and the waiting rooms were ripped away. The surge rushed toward Grapeville, where the cataclysmic waters pushed debris into the viaduct and underpass of the Pennsylvania Railroad. The water eventually overflowed and washed out the tracks before continuing to flood into downtown Jeannette, West Jeannette, Penn Station, and finally into Irwin, where it found a less-confining plain and, at last, played out.

Oakford Park would later recover, rebuild, and return as the place for fun and amusement for the next 93 years.

One

THE BIRTH OF JEANNETTE

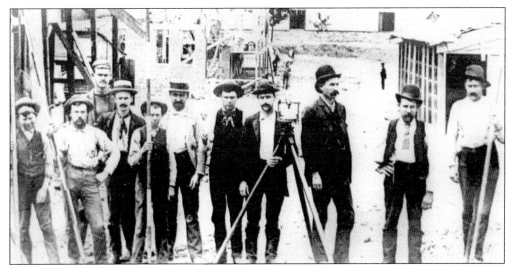

In partnership with the Western Land and Improvement Company of Philadelphia, H. Sellers McKee, along with James Chambers and David Z. Brickell of Pittsburgh, hired surveyors to lay out the new city on the farmland that had been purchased in the spring of 1888 from J. F. Thompson, Soloman Loughner, and J. F. Gilchrist. Here a crew surveys the area of Sixth Street for construction of row houses.

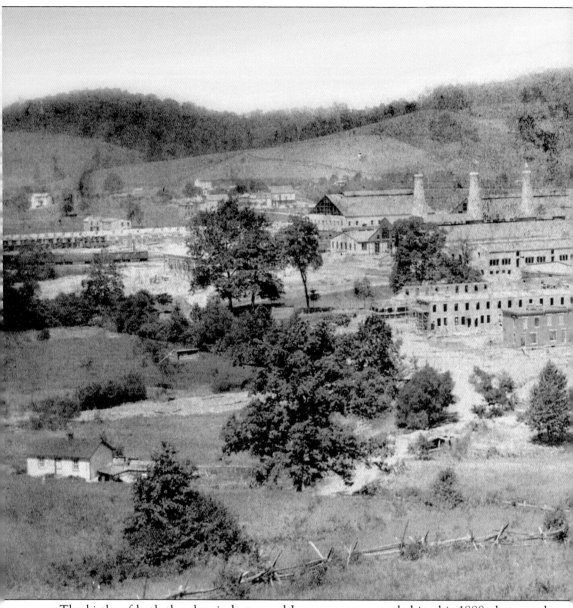

The births of both the glass industry and Jeannette are revealed in this 1888 photograph. The construction of the Flint Glass Works by H. Sellers McKee marked the beginning of the glass business in the area. The industrial section and worker housing were originally

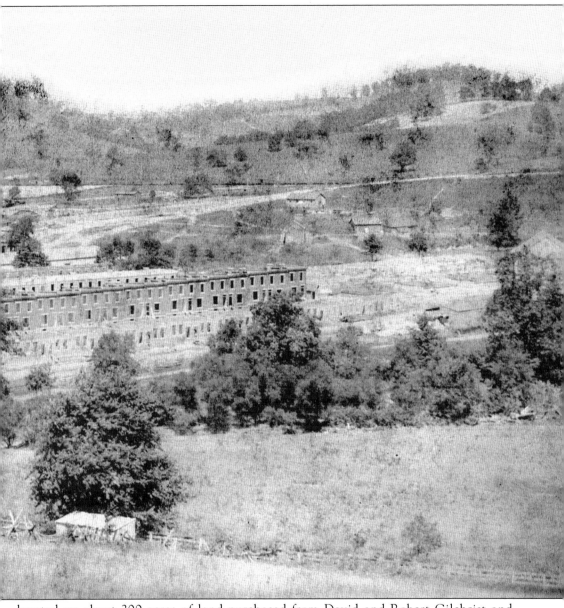

located on about 200 acres of land purchased from David and Robert Gilchrist and Fullerton Thompson Farms. Jeannette is located in southwestern Pennsylvania, approximately 25 miles east of Pittsburgh.

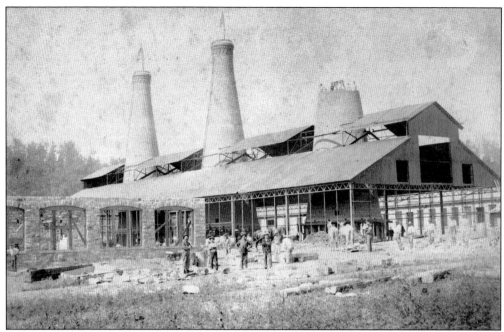

Due to the lack of space and increased cost of fuel, H. Sellers McKee decided to relocate his glass business from Pittsburgh to what is now Jeannette. One of the main reasons he chose the new site was the supply of cheap natural gas found in the Grapeville area, adjacent to Jeannette. The first glass factory in Jeannette, pictured here, was built in 1888 by McKee Brothers.

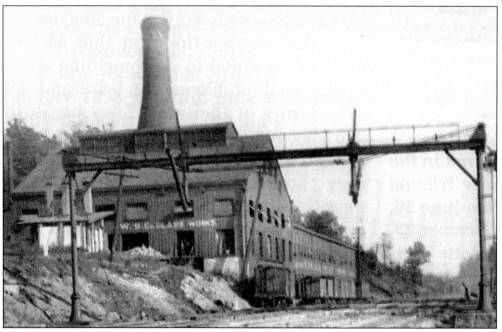

The Westmoreland Glass Works, originally called the Westmoreland Specialty Company, began operations in February 1889. Maj. George M. Irwin was president; George R. West, vice-president; and Charles H. West, secretary and treasurer.

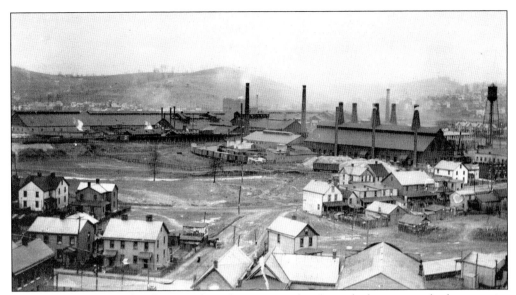

This early view of the glass factories shows how near to the plants the homes were built, a practice that was convenient for the workers. Life in early Jeannette revolved around the glass industry. Note the horse-drawn wagon on Mill Street, seen in the center foreground.

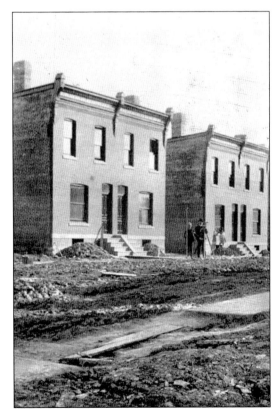

The construction of row houses on South Sixth Street began in 1888. They would be modern, comfortable homes for glass factory workers, built of brick with front stoops and small lawns to the sidewalk.

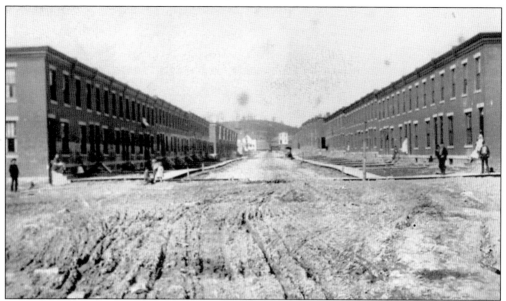

South Sixth Street was one of the first areas to be developed in the new city of Jeannette. The brick structures had everything the glass workers needed for raising their families, and were located close to the factories.

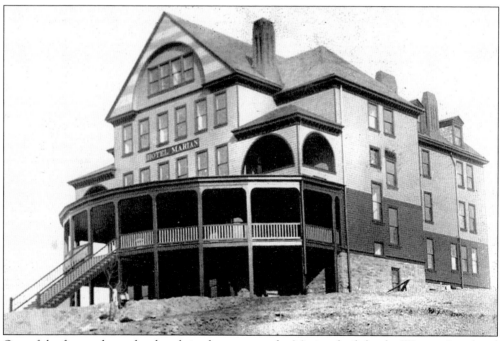

One of the first and grandest hotels in the area was the Marian, built by the Western Land and Improvement Company. A pretentious structure, it was the center of the very gay social life that characterized the town in those early years. The proprietor, a Mr. McKelvey, catered to a large group of young men who came to Jeannette to seek their fortunes in the glass factories.

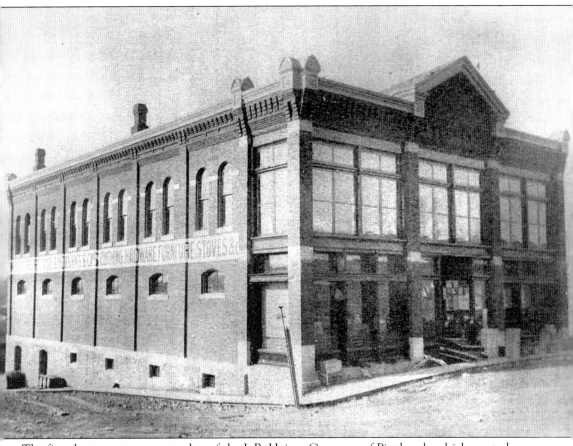

The first department store was that of the J. B. Haines Company of Pittsburgh, which erected a temporary structure at the corner of Third and Clay while the brick building shown here at the corner of Clay and Second was completed. Dry goods, groceries, and shoes were sold on the first floor; furniture and carpets were on the second floor. The post office was also located in the building, with J. B. Haines as postmaster.

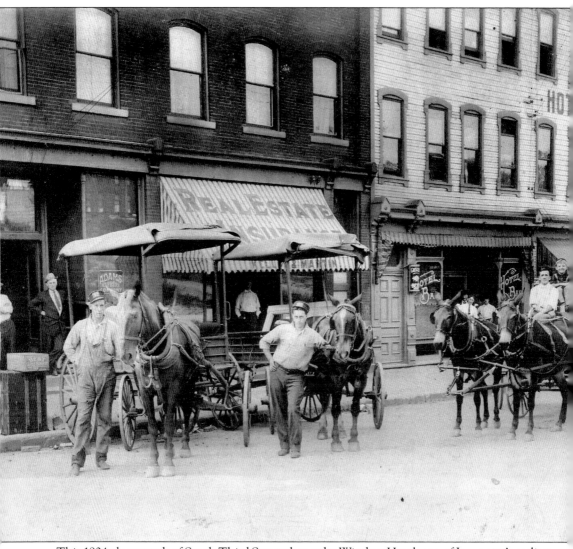

This 1904 photograph of South Third Street shows the Windsor Hotel, one of Jeannette's earliest hotels. It was located close to the railroad and was one of the most popular hotels of the day. The building next to the Windsor held a real-estate office and, over the years, a variety of stores. Today, the Windsor Hotel building houses a popular restaurant.

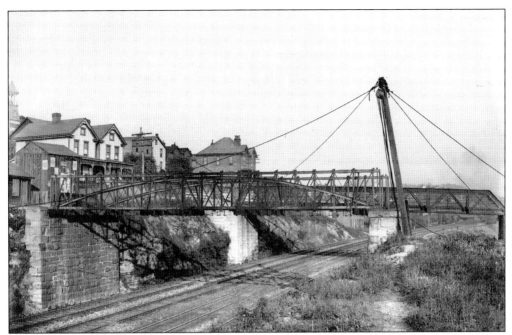

One of the earliest structures to be built over the railroad tracks was the Seventh Street walking bridge. Jeannette was growing, and access to Gaskill Avenue was needed.

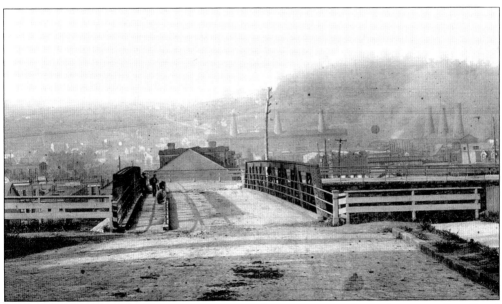

Because the rapid growth of Jeannette necessitated easier access to the section across the railroad tracks, the Seventh Street vehicle bridge was constructed. With the Second Street and Seventh Street bridges now completed, all of Jeannette was easily accessible.

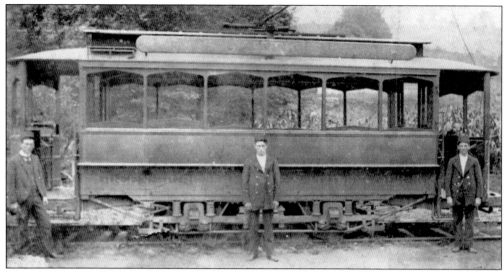

The growing population of Jeannette also required public transit. The trolley was therefore introduced in the 1890s, making possible jaunts to neighboring towns. A trolley park on the outskirts of the city was built in 1895.

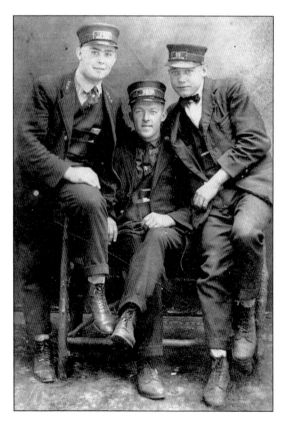

Three trolley conductors are shown in this photograph from the early 1890s. The jackets, badges, and hats were all part of the official uniform of the day.

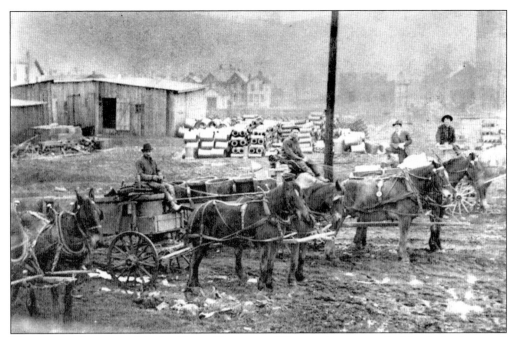

This is an early scene of the building of Jeannette. The supplies are stacked in the background, waiting for horse-drawn wagon to haul them to their destinations. The muddy yard gives an indication of the speed at which these businesses were erected, leaving no time to pave lots.

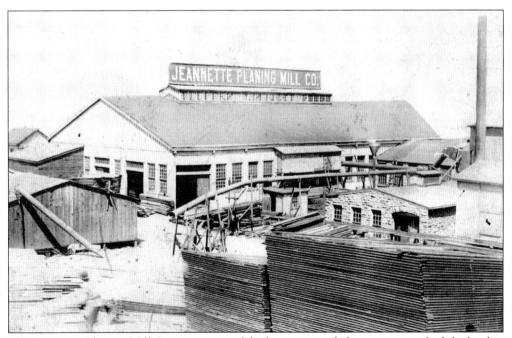

The Jeannette Planing Mill Company, one of the busiest in early Jeannette, supplied the lumber needed for the building of the town. The mill also produced 1,000 boxes per week for packaging in the glass industry. The box shop of the mill employed 40 workers.

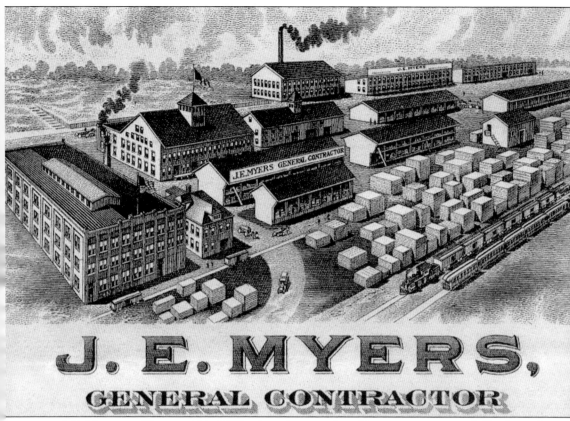

J. E. MYERS,
GENERAL CONTRACTOR

J. E. Myers was 19 years old in 1888, when the new city of Jeannette was started. Not long after that, he began to build houses. Then, in 1895, he decided to branch out, founding the J. E. Myers Lumber Company with $500 in capital. Myers was responsible for the construction of 230 homes in Jeannette, four churches, three schools, the Glass City Bank, the News Dispatch Building, and many other structures.

Two

INDUSTRY

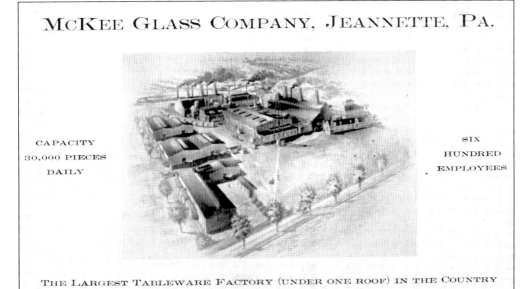

MCKEE GLASS COMPANY, JEANNETTE, PA.

CAPACITY
30,000 PIECES
DAILY

SIX
HUNDRED
EMPLOYEES

THE LARGEST TABLEWARE FACTORY (UNDER ONE ROOF) IN THE COUNTRY

This postcard of the McKee Glass plant was sent out to its 600 employees. The back of the card reads, "To our employees we appreciate your effort in assisting to increase the business for the past year. It shows that you have put forth your best effort and have pride in your work. With the two weeks vacation now at hand, we hope you will be greatly benefited. The Plant will resume work July 15th, 1912."

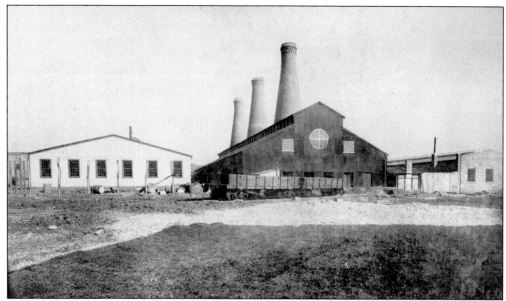

This late-1880s photograph shows the McKee Brothers Flint Glass Factory, which was built in a field and connected to its outlets by the railroad. The glass factories were constructed first and then the town grew up around them.

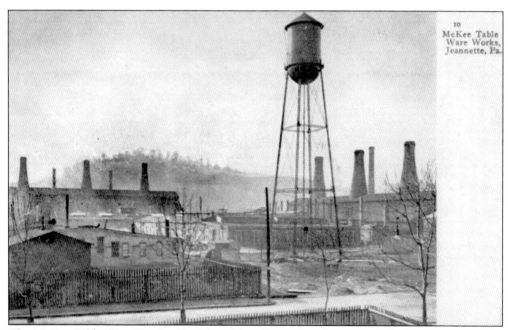

The McKee Table Ware Works (the Flint Glass Factory) is shown, with Bullitt Avenue in the foreground. The huge water tower was a well-known landmark in Jeannette.

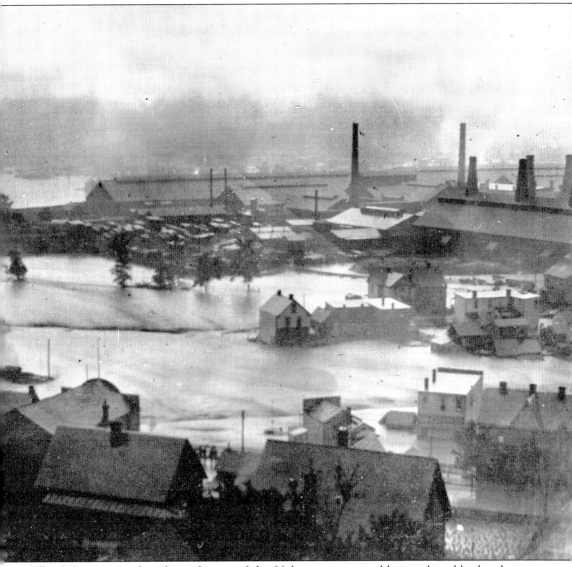

A flood that occurred in the early part of the 20th century proved how vulnerable the glass factories were. Early Jeannette had no flood control, and the glass factories were constructed without thought to the safety of the locations.

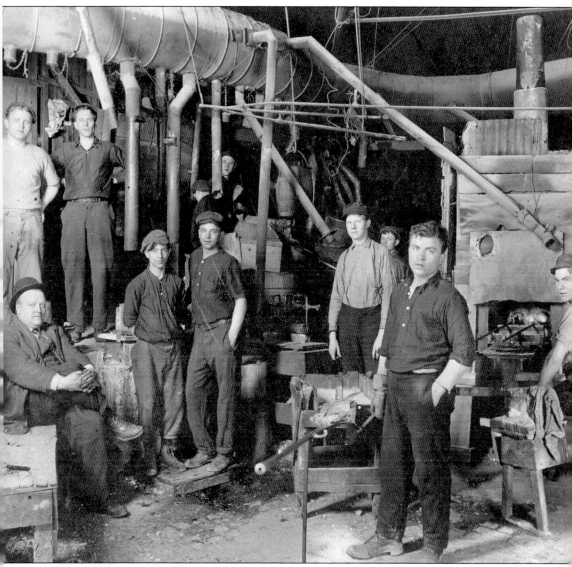

This photograph was taken inside Jeannette Glass, also known as "The Fizzle," around 1910. ("Fizzle" was a nickname for the sparks that flew from the molten glass.) The boss is seated at the left. At upper left, in the white shirt, is William Wandel, great-grandfather of Amy Englehart. The workers appear to be of a very young age. This was before the establishment of child labor laws.

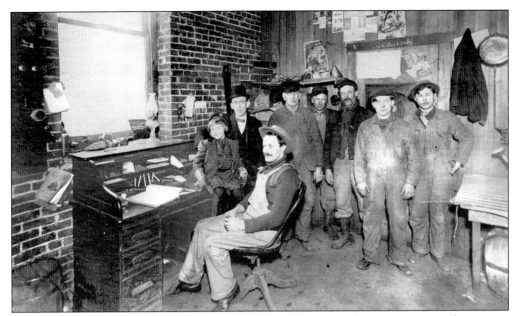

In this 1912 photograph of the Westmoreland Glass Cutting Shop, one can see the various ages of the workers before child labor laws. The Westmoreland Glass Works began operations in February 1889.

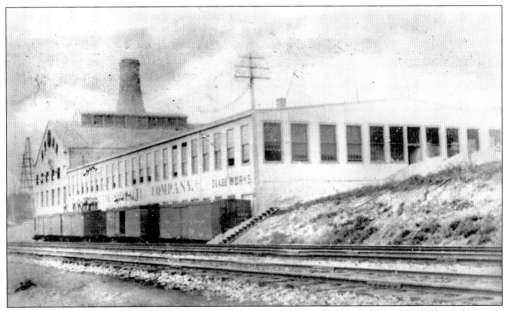

The Westmoreland Specialty Company of Grapeville, seen here in 1891, would later become Westmoreland Glass. Note the gas well at the far left.

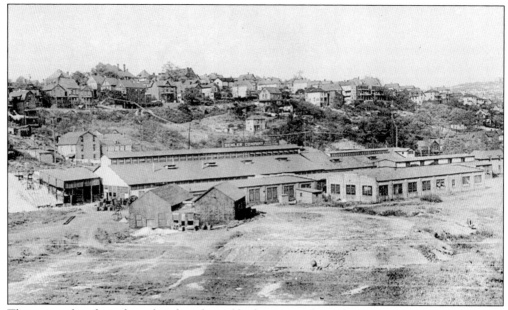

This view, taken from the railroad tracks and looking toward North First Street, shows the Semler Company in the early 1900s.

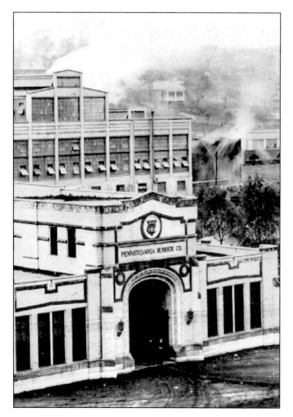

The Pennsylvania Rubber Company moved to Jeannette in 1902. Articles manufactured at that time were solid tires, bicycle tires, and a complete line of mechanical rubber goods. The arch in this photograph is a well-recognized entrance to the company.

Joe Potts, left, and an unidentified friend were rubber tire builders at the Pennsylvania Rubber Company.

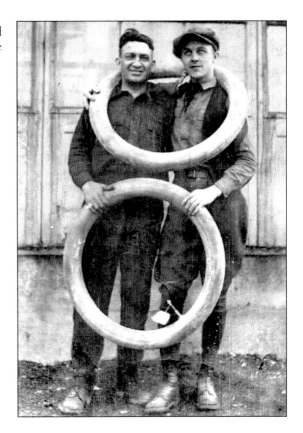

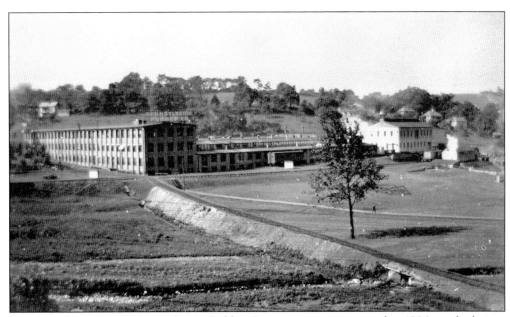

The first addition to the Pennsylvania Rubber Company was constructed in 1906, at which time the manufacture of automobile tires commenced. This 1907 view shows the beautiful rolling hills and lawns surrounding the factory.

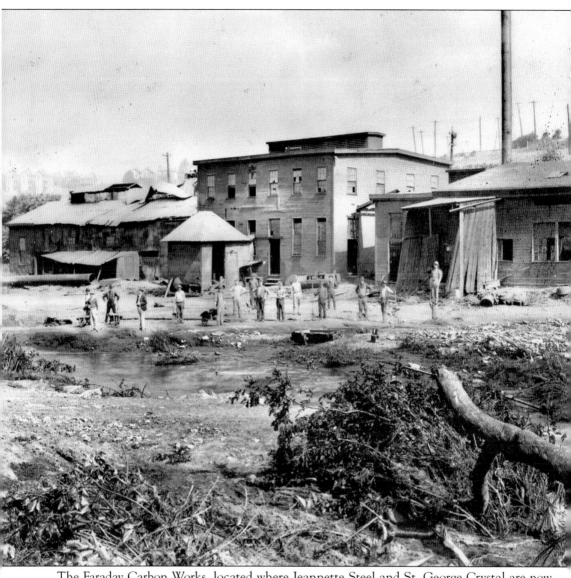

The Faraday Carbon Works, located where Jeannette Steel and St. George Crystal are now situated, was an early town industry. This photograph was taken shortly after the 1903 Oakford Park flood. The Faraday Carbon Works burned to the ground a few years later.

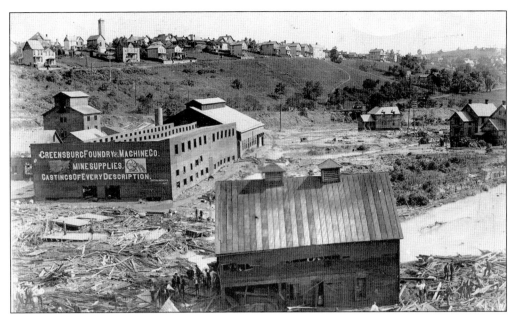

This image from the 1903 flood shows the Greensburg Foundry at left center. On the hill behind the factory, on North First Street, the tall structure of Hose Company No. 4 is visible. The box factory is now located where the Greensburg Foundry once stood.

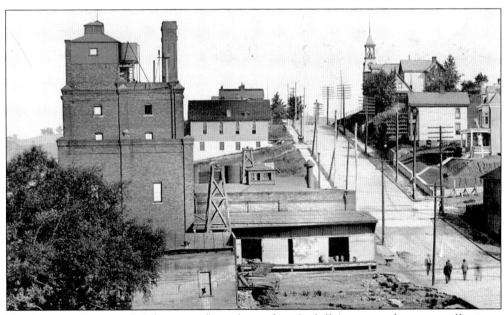

The Jeannette Brewery (left foreground) was located on Gaskill Avenue and went out of business in the early years of the 20th century.

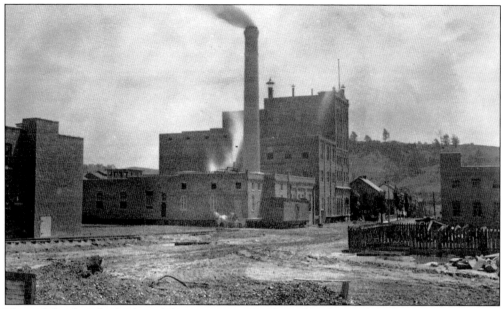

Through hard work, thrift, and determination, Frank Maddas founded the Masontown Brewing Company, serving as its president until 1907, when he moved to Jeannette. In Jeannette, Maddas organized and ran the Victor Brewing Company, which is shown in the photograph above soon after it opened. The business survived prohibition to brew more than 100,000 barrels per year under the Old Shay and Steinhouse labels until the 1930s, when the brewery was sold to the Fort Pitt Brewing Company. The same facility is pictured below in the mid-1950s, when it was again up for sale.

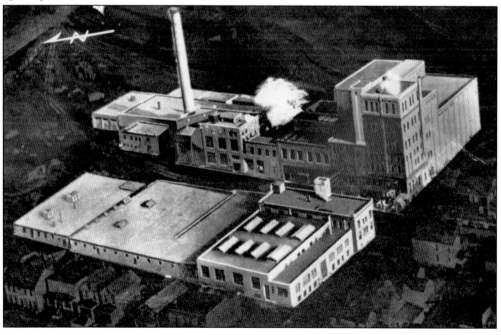

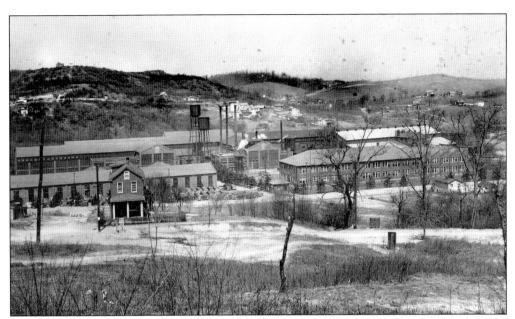

The Elliot Company is shown here about 1930, when houses had not yet been built on Fourth Street.

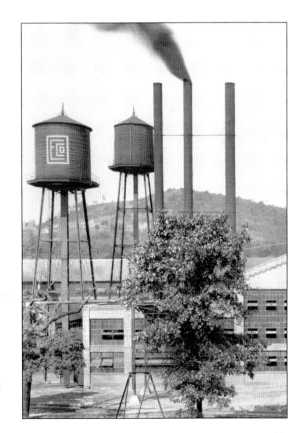

The landmark water towers at the Elliot Company are seen in this photograph taken from Fourth Street.

An early industry of Jeannette was the M. H. Miller Toy Company, which was located near the creek and faced south on Elliott Company property.

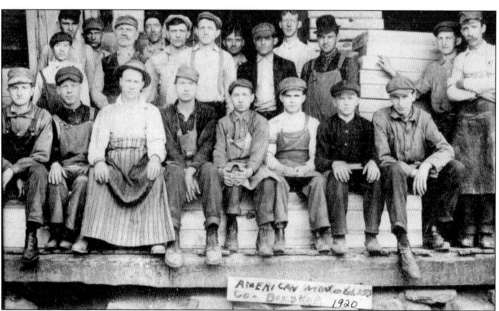

The largest window-glass factory in the country when it was constructed in 1888, the American Window Glass Company of Jeannette embodied the first three generations of window-glass technology: artisanal production, Lubbers technology, and Fourcault machinery. Until it closed, this was the last plant in North America using the Fourcault machines. This photograph shows the company box shop about 1920.

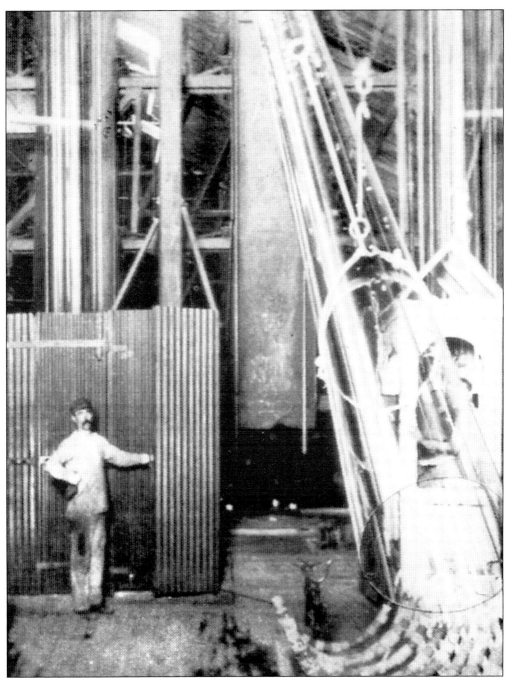

Note the large cylinder at right; it is a Jeannette "first." Revolutionizing the art of melting window glass, the first continuous window-glass melting tank in the world was built at a Jeannette factory, the American Window Glass Company, in the year 1888. Although dire failure was predicted for this bold venture, from the start it was successful in the continuous and regular production of fine glass, superior in quality to that melted in pots.

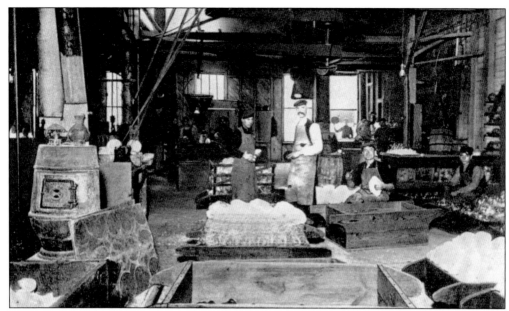

During World War I, the American Window Glass Company was the only manufacturer in the country that could make the kind of glass required for eyepieces for gas masks. These were made of very thin glass circles about two and one-half inches in diameter and laminated, making the glass non-shatterable—in other words, safety glass. The use of these laminated eyepieces in gas masks is believed to have reduced by about 95 percent the incidence of eye injuries and blindness caused by eyepiece breakage.

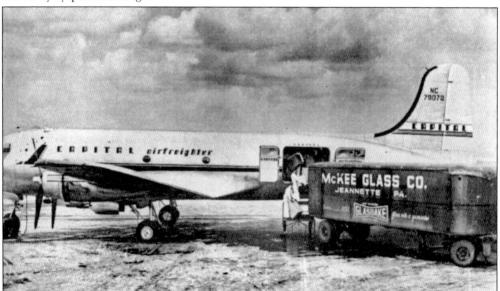

Through the patriotic assistance of the men, women, and children of a Red Cross unit who volunteered to learn how to cut glass circles for gas masks, the American Window Glass Company furnished 27 million of the circles to be used in gas masks for U.S. and Allied troops in World War I. If the glass was not perfectly flat or was not cut with a perfectly smooth edge, the celluloid used in laminating would not bind the two circles together. The company continued to prosper, as this photograph shows an airplane shipping out products.

Three

DOWNTOWN BUSINESSES

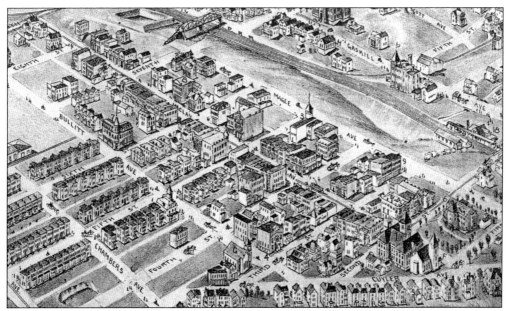

This T. M. Fowler map of downtown Jeannette dates from 1897. Clay Avenue is the main street in Jeannette. Railroad tracks are pictured at upper right.

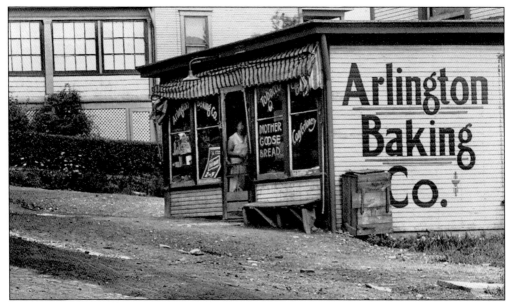

In 1933, John Ivanoff moved to Jeannette from Wilmerding, Pennsylvania, to purchase and take over the Arlington Bakery. He owned and operated it until 1946, at which time it was sold to his son Robert Ivanoff and Chris Walters.

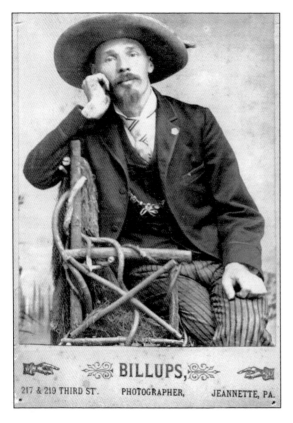

In the 1890s, photographer James Billups (who is pictured on this card), came to Jeannette and opened a studio at 217–219 Third Street. Many pieces of his work survive today and demonstrate a quality superior for the time.

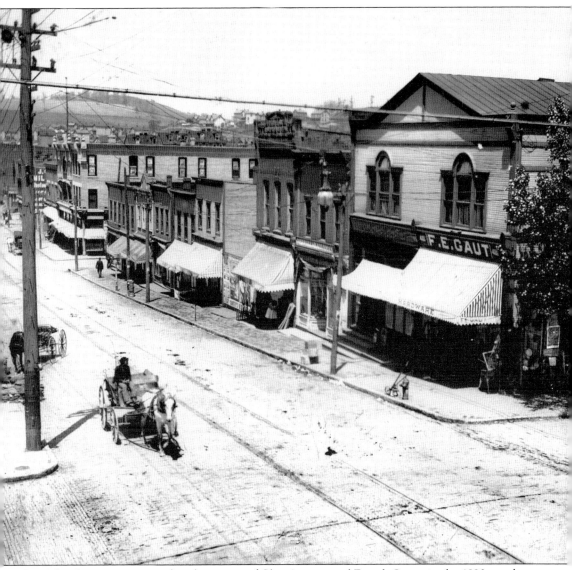

Gaut's hardware store opened at the corner of Clay Avenue and Fourth Street in the 1890s, and remained in business through the early years of the 20th century. It was one of the most thriving businesses in Jeannette.

The building on the right is the Peoples National Bank, organized on June 17, 1905, with capital of $50,000 by J. Collins Greer, Edmund Fisher, John Sowash, Matthew Black, Alf T. Smith, Newton J. Baxter, and R. W. Borland, who served as the first board of directors. By 1927, the bank had total resources of $1.5 million. The bank's officers at the time were J. Collins Greer, president; W. D. Robinson, vice-president; and C. A. Nelson, cashier. The Peoples National Bank was sold to the First National Bank on June 22, 1927.

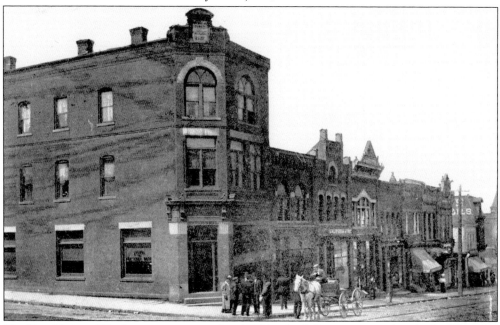

The First National Bank was incorporated in 1889 by the following men, who also had founded Jeannette the preceding year: H. Sellers McKee, D. Z. Brickell, Charles R. Smith, Thomas M. McKee, Frank B. Pope, John Barclay, James A. Chambers, William S. Jones, George E. Moore, Samuel H. Weaver, and Lucien W. Doty. The bank opened for business with H. Sellers McKee as president and Charles R. Smith as cashier.

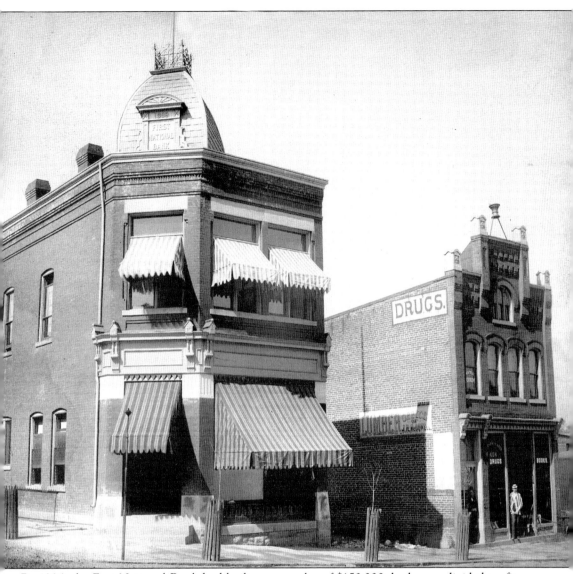

By 1906, the First National Bank had built up a surplus of $150,000, had an undivided profit account of $35,000, and paid dividends of $336,500. During the panic of 1907–1909, the First National Bank was the only one in Westmoreland County that was in a position to care for its depositors in U.S. currency, while other banks were more or less required to use scrip.

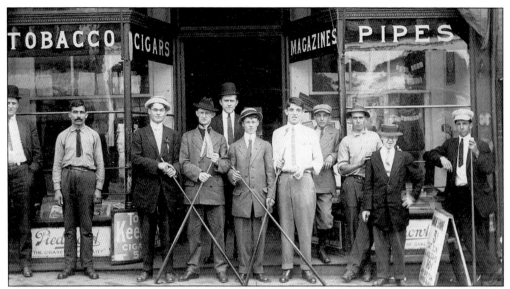

The McKee Billiard Parlor, owned by Ezra W. Copper, was located across from city hall in the McKee Hotel, at 119 South Second Street. The parlor also sold tobacco, pipes, and magazines and was one of the most popular establishments in Jeannette.

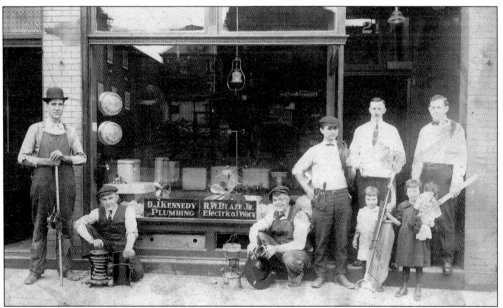

D. J. Kennedy Plumbing and R. W. Blaze Jr. Electrical Work were situated at 219 South Fourth Street. Some of the merchandise sold by the store were fans, toilets, sinks, and plumbing fixtures. Small appliances such as sweepers and fans were also repaired.

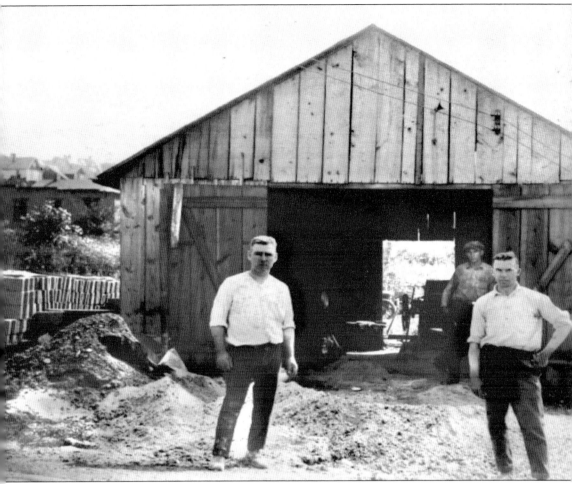

On Harrison Avenue, across the street from the Elliott Company, was the Jeannette Block Company. This 1923 photograph shows the cement blocks on the left and the equipment in the shed. The business was located in a rather simple building, but still produced enough cement blocks for the expanding town of Jeannette. Rubble stone foundations had been used in the early buildings. But when larger and more expensive homes and structures were built, the need for cement blocks grew. Building with cement block was a faster method of construction.

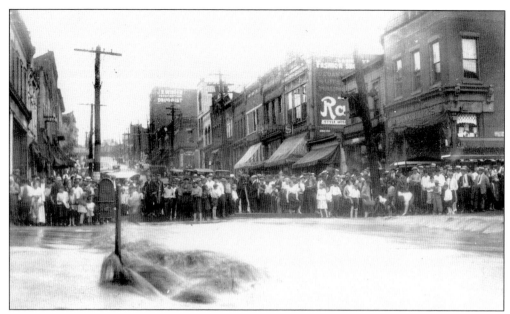

In this photograph showing the flood of June 1921, Levy's Clothier appears on the right; up the street, Ratner's sign is visible; and the J. C. Penney building is at the top. This view was photographed at Clay Avenue and Fifth Street, the lowest section of Clay Avenue.

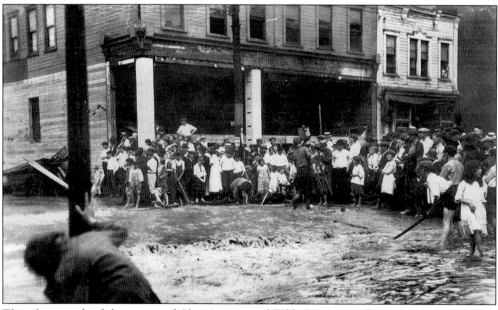

This photograph of the corner of Clay Avenue and Fifth Street reveals the building that once housed the Photoplay Theater. This location later became the home of the Manos Theater, and the adjacent building was eventually occupied by Benevantano's Restaurant. The June flood of 1921 damaged these structures.

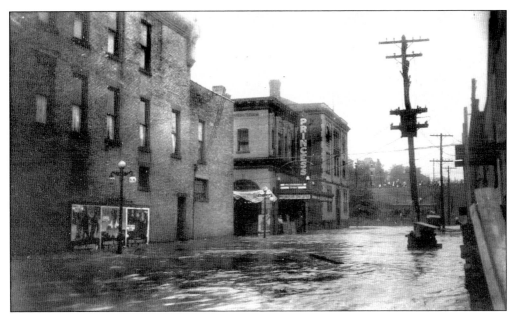

Looking north on Fifth Street, this view shows the side of Ely's Department Store in the left foreground. On the building there are posters advertising the movie that is playing at the neighboring Princess Theater, which is at middle left. The last building on the left, just beyond the Princess, is Turner Hall. On the hill in the distance, people are lined up on the railroad tracks, observing the June 1921 flood waters. The Princess Theater eventually became the Kihchel Theater, and after that, the American Legion building. Turner Hall later became Pitzer's Restaurant.

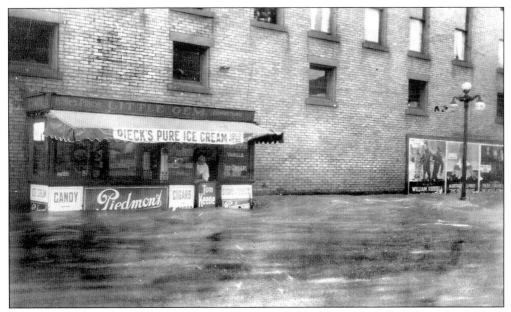

Attached to the side of Ely's Department Store on Fifth Street was Billie's Place Little Gem Confections. Here, owner Billie Guest, a well-known Jeannette businessman, stands in his shop as he braves the 1921 flood.

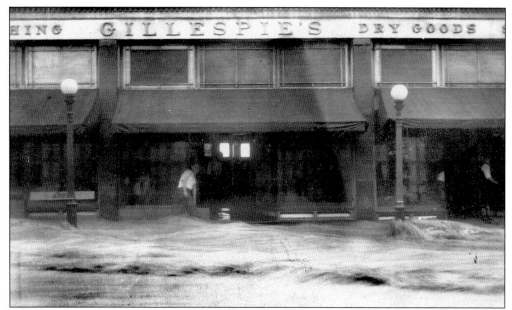

Gillespie's was located on the corner of Clay Avenue and Fifth Street. The store dates back to the very first days of Jeannette. In fact, it was here before there was a post office or a railroad station. Gillespie's first operated as a small shoe store, at 411 Clay Avenue, and later moved to 408 Clay Avenue. The store survived the 1921 flood and continued in business for another 60 years.

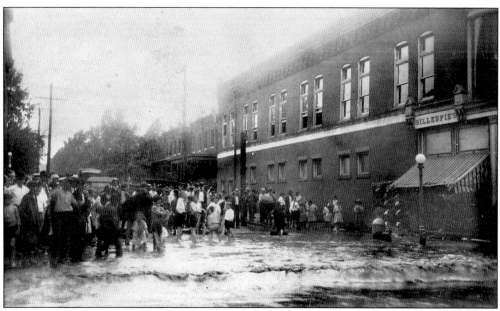

Looking south on Fifth Street, this view shows the side of the Gillespie's store. Behind Gillespie's are several row houses. These were torn down approximately 10 years later, and the Jeannette Post Office took their place. The children in the street appear to be enjoying the waters of the 1921 flood.

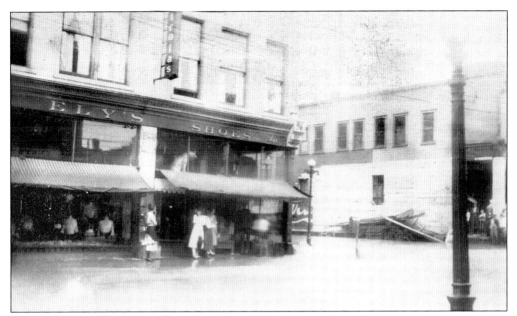

In 1890, Nelson Ely came to Jeannette from Covington, in Tioga County, as a glass blower for the Chambers-McKee Works. He and his wife lived in rooms on Fifth Street. The next year, the couple moved into half of a house built by Alfred St. Peter, whose wife ran a millinery store in town. In 1891, Nelson's brother John arrived, and the two started a clothing store on Clay Avenue. Soon, their brother Charles joined them and the firm of Ely Brothers flourished.

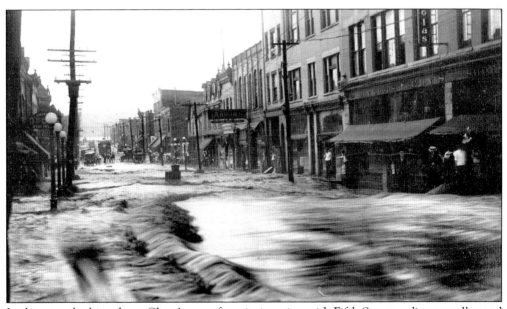

In this view, looking down Clay Avenue from its junction with Fifth Street, a distant trolley and cars are stopped where the waters ended. The moving water splashes against the utility poles and buildings during the 1921 flood.

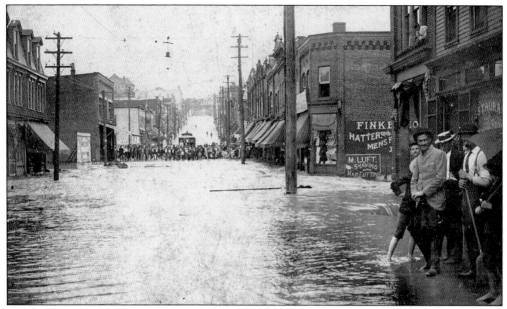

Looking east on Clay Avenue, this view reveals the effects of a flood in the mid-1890s.

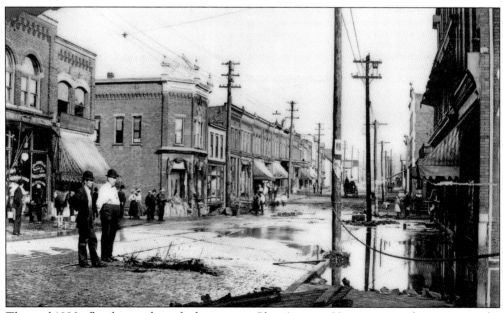

The mid-1890s flood caused much damage on Clay Avenue. Here, two gentlemen assess the torn-up bricks and water damage at Sixth Street and Clay Avenue.

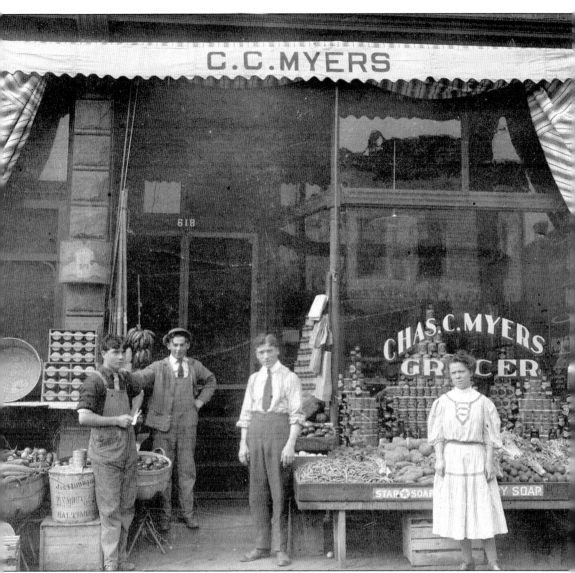

Grocer Charles C. Myers had a store at 618 Clay Avenue. He carried almost everything needed by the typical household; soup, canned goods, oysters, corn, cabbage, onions, green beans, peppers, and mops were among his supplies.

Roland Merrill (far left) and Robert M. Baughman (far right) owned the Merrill-Baughman Jewelry Store at 400 Clay Avenue. The young boy, Foster Steiner (second from left), was a town hero who once thwarted a robbery at the store. The man at center is unidentified.

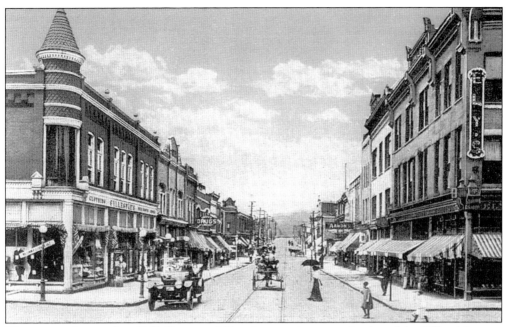

This postcard image from Fifth Street and Clay Avenue gives an early view of the Gillespie's store, Ely's department store, and the awnings common to the storefronts of that period. Motorcars shared the road with horse buggies.

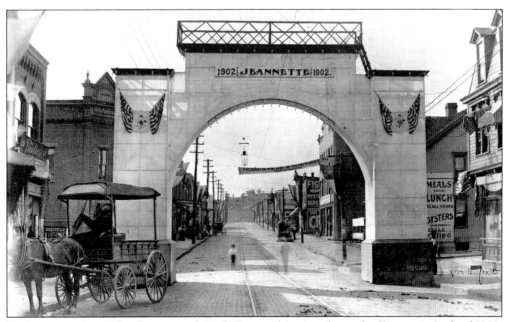

Looking west from Clay Avenue and Sixth Street, this view shows the Fireman's Arch of 1902, which was built for the Fireman's Day parade of that year.

The horse and wagon is parked in front of Jacob's Meat Market in the 600 block of Clay Avenue. The A&P, Seiler's, and Aaron's can also be seen.

This 1928 photograph of the Albert Elias Dry Cleaning Shop, at 122 South Third Street, advertises the tailoring services of cleaning, pressing, and repairing.

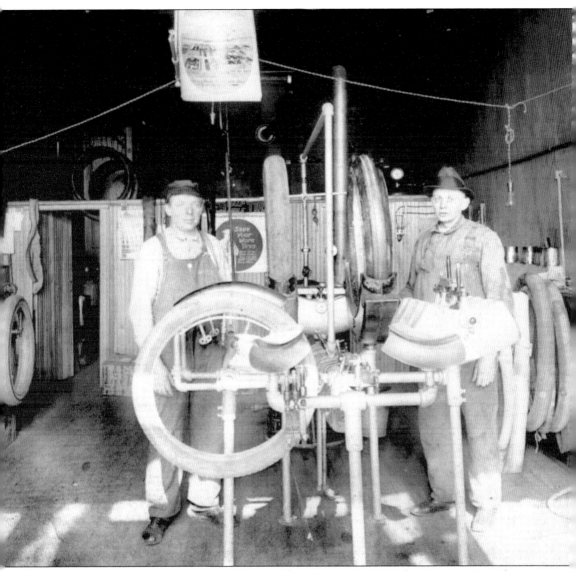

The tire repair shop of Frank Lecas and his son Ed was located at 715 Clay Avenue. Note the types of equipment used in repairing tires. In those days, tires were bought and kept as long as possible because of the initial expense of purchase.

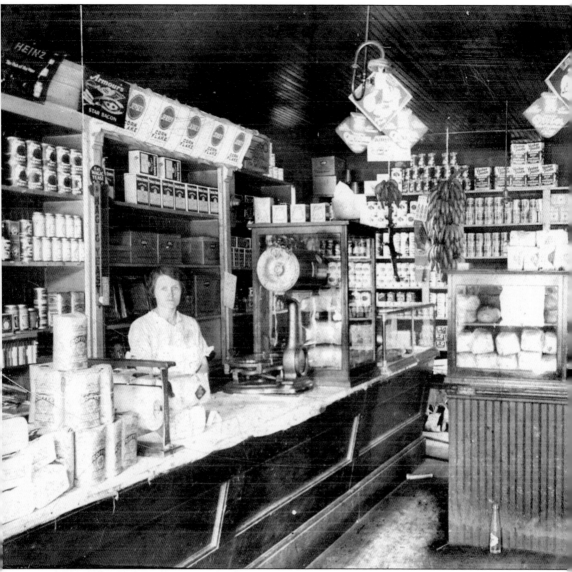

Mrs. Alice Steiner Groceries, built in 1914, was located at the corner of Lewis Avenue and Route 30. This photograph shows the interior, with the items sold there. Alice's husband, Walter, died in 1919. Alice eventually closed the store in the mid-1930s because too many people were shopping on credit.

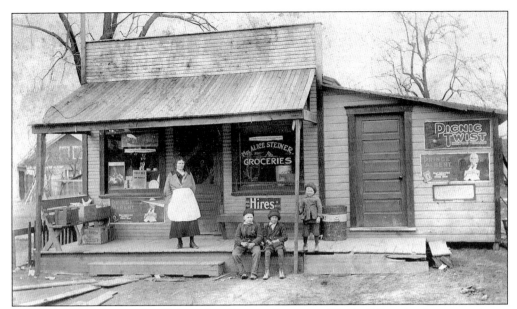

Alice stands on the porch of Mrs. Alice Steiner Groceries. The building, landscape, and area appear very rustic.

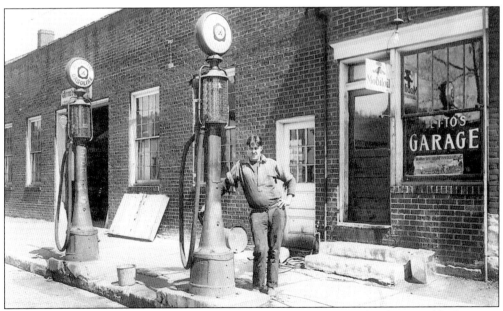

Getto's Garage, located on Twelfth Street in West Jeannette, was owned and operated by Domenic Getto. Note the old-fashioned gas pumps.

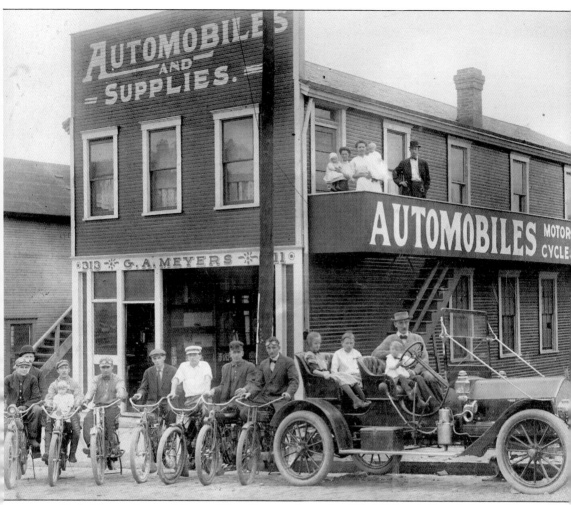

G. A. Meyers Automobiles and Supplies was situated at 311–313 South Fourth Street. The 1919 building sign advertises "Automobiles and Motor Cycles." The Meyers family lived on the second floor, which had a balcony.

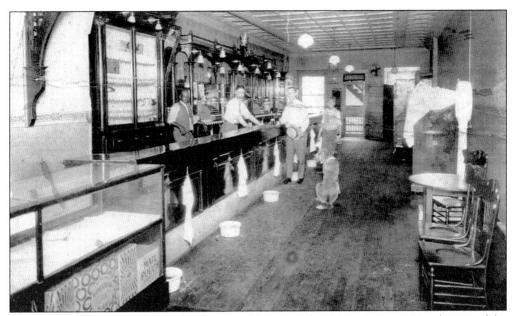

Here is an interior view of the Brass Rail bar at the Clay Avenue Hotel, owned by Joseph Musick, the former proprietor of the Marian Hotel. Seen here in the 1920s, it was located at 720 Clay Avenue. Note the spittoons on the floor. Joseph Musick was a well-known businessman of early Jeannette.

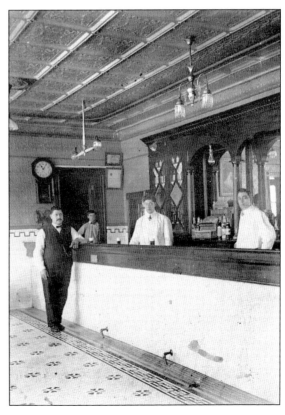

Jean Baptiste Monier (May 10, 1869 – November 11, 1913) was the owner and bartender of the Monier Hotel. In later years, it became the Hollywood Bar, which burned in April 1977.

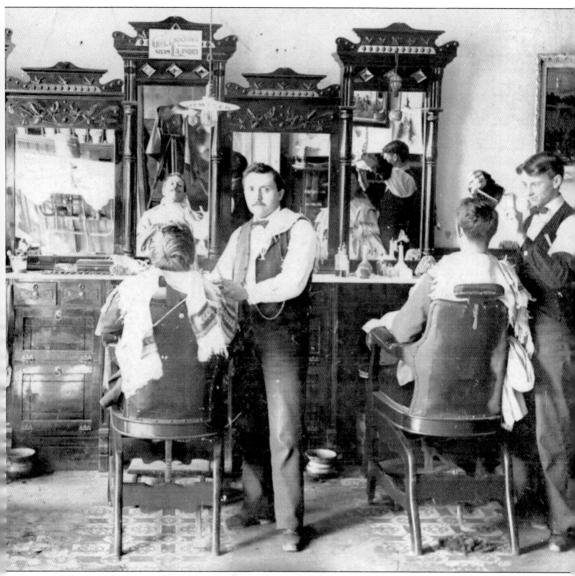

The Fourth Avenue Hotel was built in 1891, and in the 1890s, Ed Gaughan operated his barbershop in the basement. Note the cameraman and camera in the mirror above the barber chair at left. The old wooden barber chairs were very different from the chrome and porcelain chairs that came later. Eventually, this became the barbershop of Melsie Antonacci.

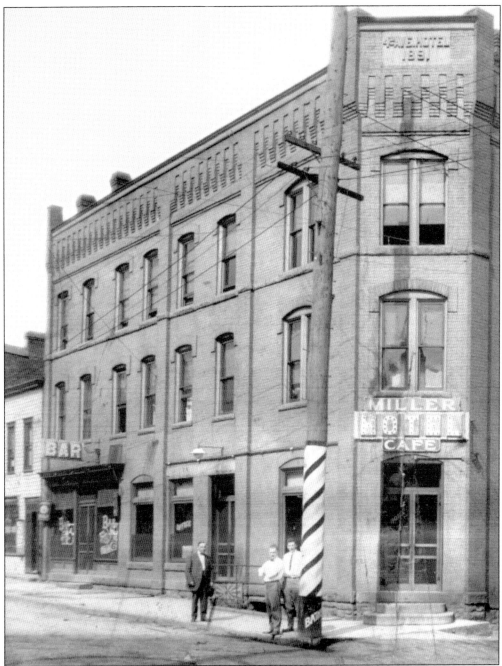

Shown here is the exterior of the Fourth Avenue Hotel, which was built in 1891. On its first floor, the building housed the Miller Hotel Cafe, a bar, and the hotel office. A barbershop was in the basement. The upper floors contained the guest rooms. An unusual feature was the barber's pole painted on the utility pole out front. The Fourth Avenue Hotel was one of the earliest and most important hotels in Jeannette, and it provided the most modern conveniences available to its patrons.

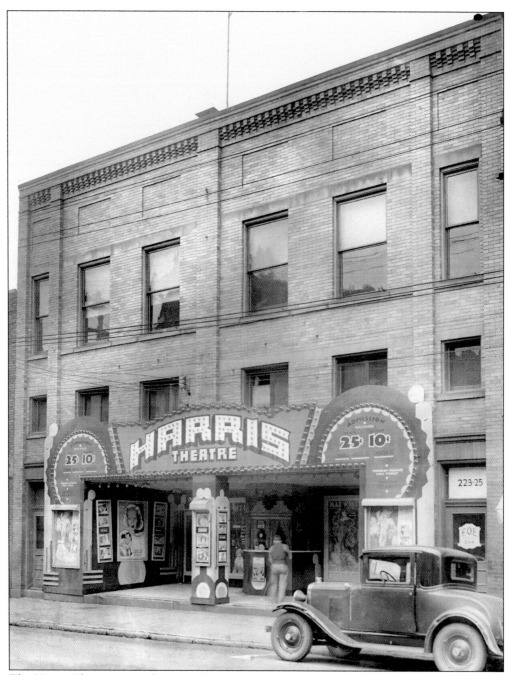

The Harris Theatre opened on October 4, 1933. On December 10, 1910, Oliver Kihchel and August Schmidt (chief of police) had established the Eagle Theater here on South Fourth Street. About four years later, Kihchel bought out Schmidt's share of the business. Kihchel ran the theater until he sold it to the Harris Company in 1933, after which time it became known as the Harris Theatre.

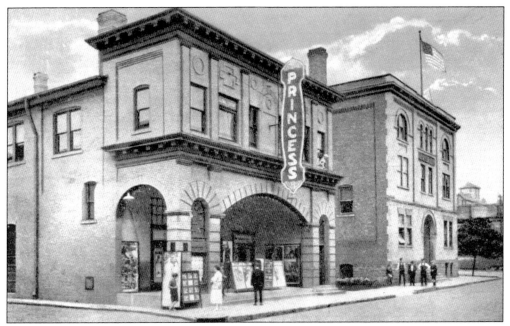

Oliver Kihchel opened the Princess Theater on South Fifth Street in 1925. With help from his family, he ran the theater until his death on September 3, 1946. In 1950, the Princess was remodeled, and the grand opening of the new Kihchel Theater occurred on August 25.

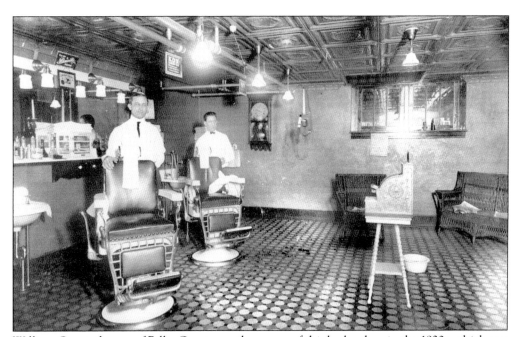

William Guest, the son of Billie Guest, was the owner of this barbershop in the 1930s, which was located where the Biltmore Bar is today. William later sold the building to Charles Vogel and then moved his shop to South Fourth Street, under Daugherty's Drug Store.

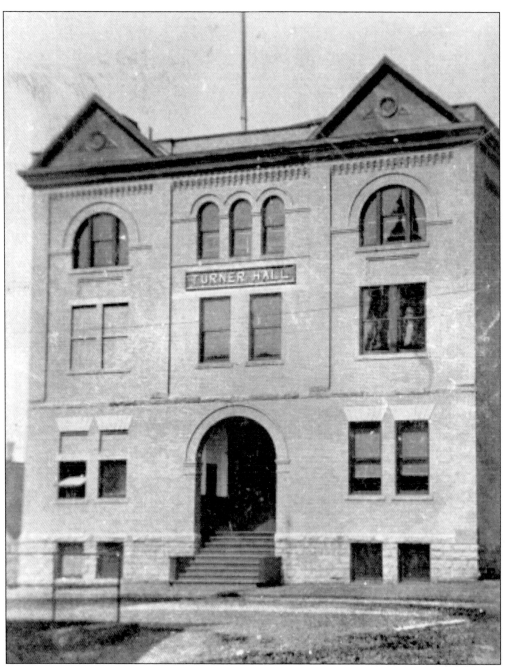

Turner Hall, at the corner of Fifth Street and Magee Avenue, opened on Monday, April 13, 1903. The building measured 100 feet by 50 feet and cost $25,000 to construct. When it opened, there was nothing of its kind in western Pennsylvania, outside of Pittsburgh, that could anywhere approach it in size and magnificence. The main entrance is on Fifth Street, and the club entrance is on Magee Avenue. Built of stone and buff brick, it is three stories high. The auditorium on the third floor is 47.75 feet wide and 67 feet long, with a 21-foot-high ceiling. The floor is laid of three-inch maple. A handsome 32-light chandelier is suspended from the center, the lights arranged in three tiers.

Four

SCHOOLS

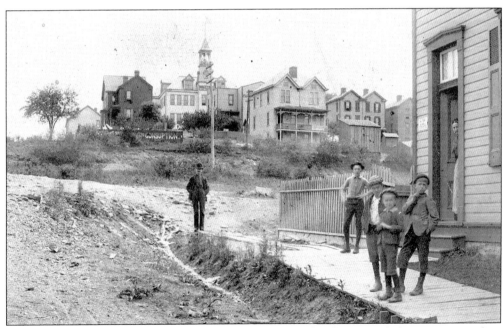

The Patton School, now known as the Gaskill Avenue School, was ready for occupancy when the school term opened in September 1890, and another year of continuously growing population witnessed a high school established in the attic rooms of this building in 1891. The high school course was covered in two years by both the class of 1893 and the class of 1894. The course was later extended to cover three years; the class of 1896 was the first to benefit from this change.

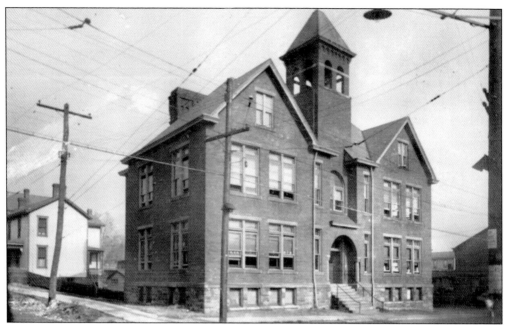

Almost before school buildings were completed, the demands for seating space had outreached the calculations of the builders. The West Jeannette School was built in 1896, soon after the Patton School graduated the first high school class to cover three years.

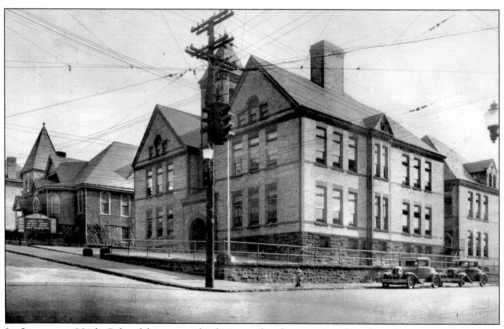

In Jeannette High School history, which is so closely associated with attic rooms, there was only one oasis. That is the brief period that the high school was "at home" in the Clay Avenue building. For this brief existence amid comparative comforts, thanks are perhaps especially due to the architect, who by accident or design, omitted a habitable attic in his plans.

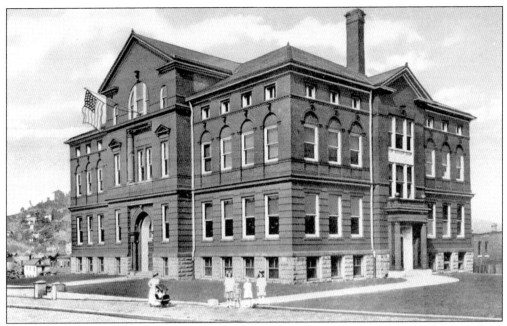

The Fourth Street Grade School was built in 1910, and before long, the third floor of the building was being used as an assembly hall for the high school, with the adjoining small rooms as classrooms. The crowded conditions of the high school caused classes to be held in the attic rooms of the Fourth Street School.

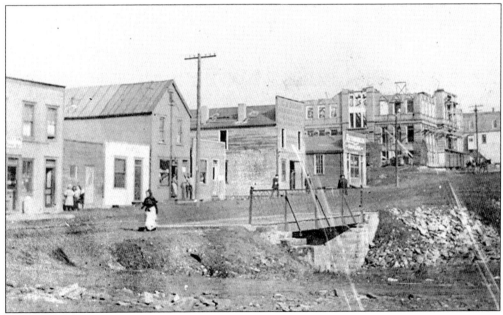

Looking up South Fourth Street from the present location of Jeannette Manor, this 1910 view shows the construction of the Fourth Street School. The school served the elementary grades, and the attic held the high school classes until Jeannette High School was built.

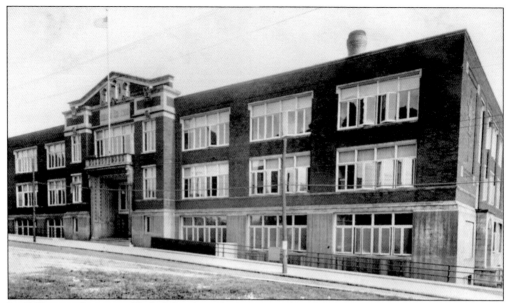

In 1922, a new Jeannette High School was built on Fourth Street, across from the grade school. The new high school was considered state of the art at the time. No longer were the attic rooms of the Clay Avenue School and Fourth Street School needed to accommodate high school students. Here, there were 32 rooms, plus a gymnasium, a 1,000-seat auditorium, a manual training department, a commercial department, a domestic science department, and science laboratories.

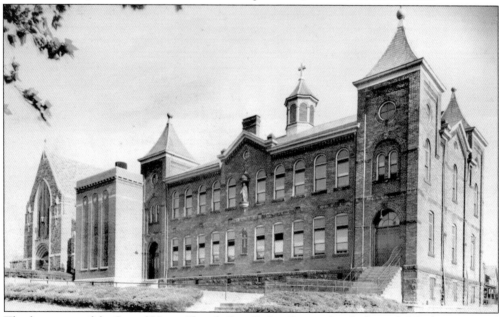

The first pastor of the Sacred Heart Church, Rev. Father Severin Laufenberg, O.S.B., began Sacred Heart School in 1890. In 1891, Rev. Pancratius Friedrich, O.S.B., applied to St. Mary's Convent, Allegheny, for religious sisters to take charge of the school. Rt. Rev. Bishop Phelan consented, and a convent and school were opened in the fall of 1891 with an enrollment of 90 pupils. Construction of the brick Sacred Heart School was begun in 1893, when the first story was erected. In 1904, the school was completed with another story.

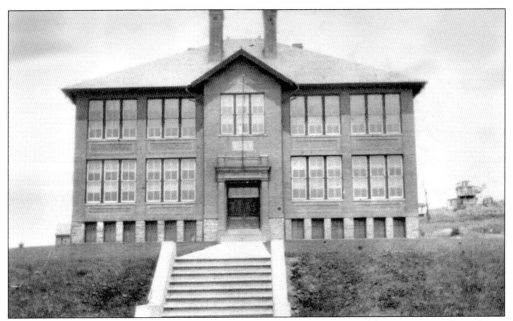

Fort Pitt School, built in 1913 on Harrison Avenue, was annexed by Jeannette from Penn Township in 1926.

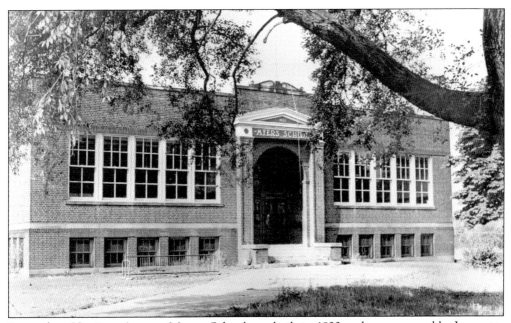

Located on Harrison Avenue, Meyers School was built in 1923 and was annexed by Jeannette from Penn Township in 1926.

Seneca Heights School was annexed from Hempfield Township in 1920. The school stood across the street from McKee Stadium.

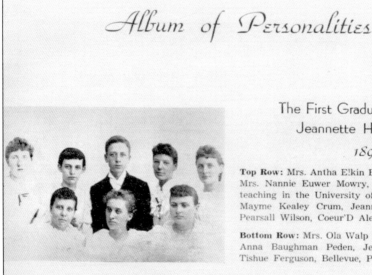

Album of Personalities

The First Graduating Class of
Jeannette High School

1893

Top Row: Mrs. Antha Elkin Breen; Chicago Heights, Ill.; Mrs. Nannie Euwer Mowry, Trafford; Edward Bennett teaching in the University of Madison, Wisconsin; Mrs. Mayme Kealey Crum, Jeannette, Pa.; Mrs. Elizabeth Pearsall Wilson, Coeur'D Alene, Idaho.

Bottom Row: Mrs. Ola Walp Havey, Swissvale, Pa.; Mrs. Anna Baughman Peden, Jeannette, Pa.; Mrs. Annie Tishue Ferguson, Bellevue, Pa.

In 1893, the first class graduated from Jeannette High School. Appearing in this class portrait are, from left to right, the following: (first row) Ola Walp Havey, Anna Baughman Peden, and Annie Tishue Ferguson; (second row) Antha Elkin Breen, Nannie Euwer Mowry, Edward Bennett, Mayme Kealy Crum, and Elizabeth Pearsall Wilson. This image was taken from the 1931 *Red and Blue* Jeannette High School yearbook.

Five

SPORTS

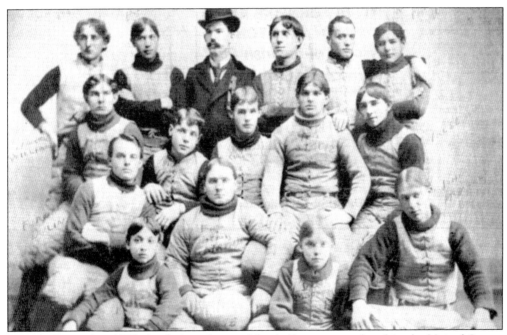

In early September 1895, the first professional football game was played in the United States. Teams from Jeannette and Latrobe participated in the contest, which saw players get paid for their services. Jeannette's George Yurt called the manager of the Latrobe team and told him he had a team of players who averaged between 150 and 160 pounds. Yurt then went around town gathering up enough men to participate in the game. This was the nucleus for the forming of the Jeannette Indians Athletic Association. The game was won by Latrobe 12-0.

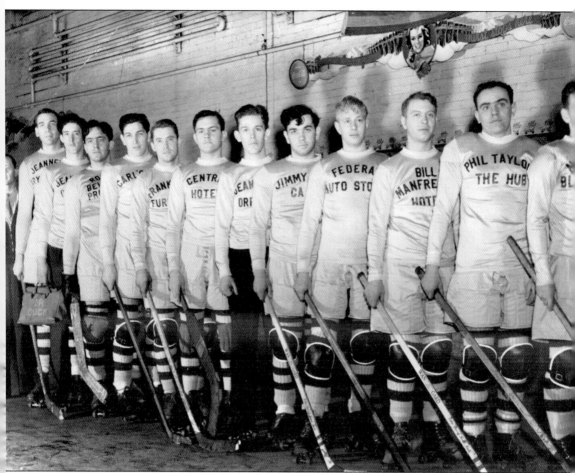

One winter sport that a large number of Jeannette's young athletes participated in between the 1920s and 1940s was roller hockey. It was one of the roughest, toughest games in the sport catalogue. The game was played on roller skates, with five men on each side. Jeannette senior teams included the Old Shays and the Lincolns of the roller hockey league and the Oakford Arrows, an independent outfit. All three could hold their own among any competition in the tri-state area. Also playing were a junior team known as the Dukes and a girls' team known as the Vanities. The league's center of activities was Jeannette, as all games were held at DelVitto's Rink.

Wilber Donner, an early football player, was photographed at the West Jeannette Field. The uniform was relatively simple, with very little chest and shoulder padding and little or no thigh padding.

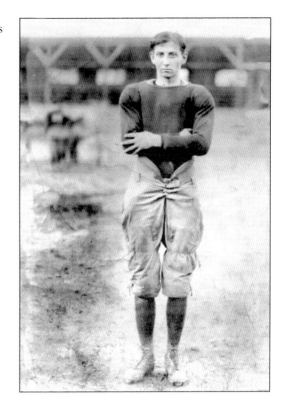

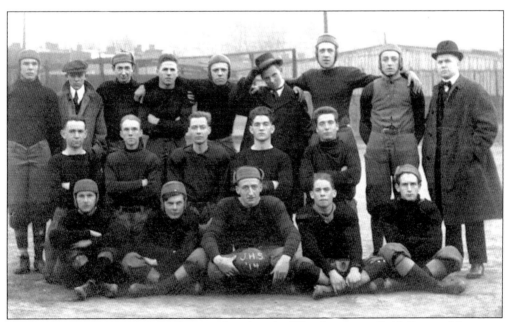

The 1914 Jeannette High School team played at the West Jeannette Field. Pictured here are, from left to right, the following: (first row) manager Rupe, Black, Kearns, Caplan, Schmertz, and Fetchner; (second row) Bricker, Gault, Madden, Maxwell, Euwer, Hagenmiller, Clippinger, and coach Dr. Jenkins; (third row) O'Connell, Pool, Duckworth, Johnson, and Slonacker.

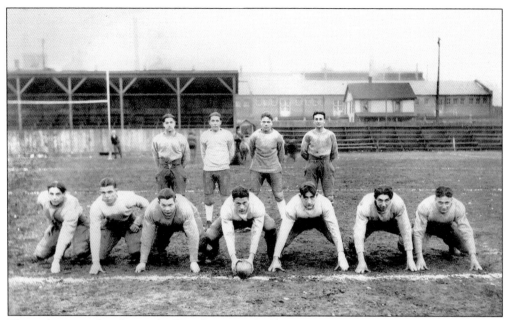

These players are lined up at the West Jeannette Field in 1927. From left to right are the following: (first row) Trumbetta, Myers, Poilek, Minkel, Stimeon, Burzer, and Plamer; (second row) Casino, Saltz, Bernard, and Zanarini.

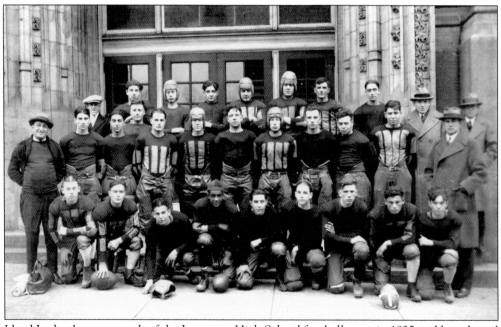

Lloyd Jordon became coach of the Jeannette High School football team in 1925 and lasted until 1927. During his tenure, the team compiled a record of 27 wins, 2 losses, and 2 ties. The Jeannette team of 1925 scored a total of 269 points, while holding its opponents to a total of 45 points.

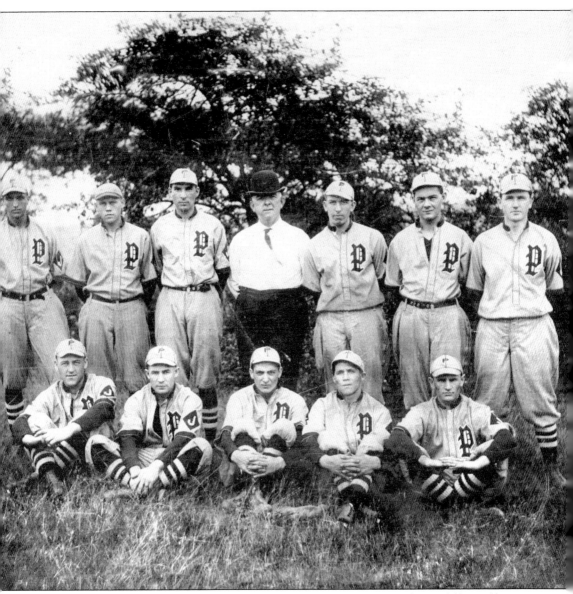

The members of this early, winning baseball team were, from left to right, as follows: (first row) Earl Weifeld, Bert Kelley, Thomas Joyce, Chick Burchell, and Ewald Deitz; (second row) Ziggy Wolf, Thomas Forsyth, Jim Daugherty, manager Happy Campbell, J. Bengal, Bill Campbell, and Joe Frye.

The 1914 Elliott Company baseball team represented the Elliott Company in inner-city games. All of Jeannette's factories had teams. Because of the lack of transportation to other cities, competition amongst inner-city teams began.

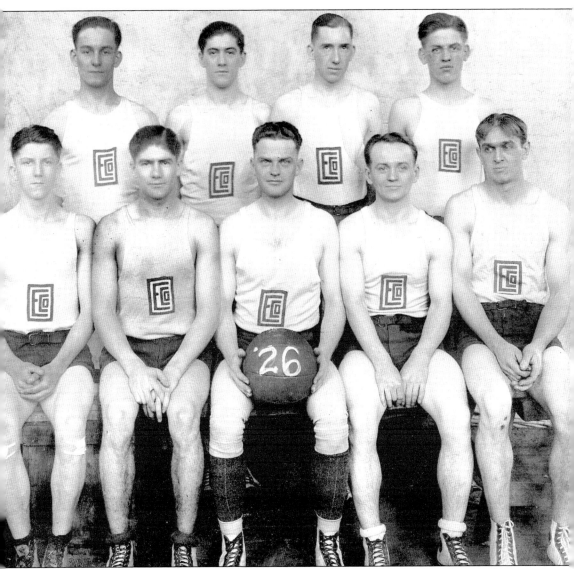

The Elliott Company had a basketball team made up of employees, who played teams from the other Jeannette factories. The Elliott Company supported its sports teams and encouraged participation by its employees.

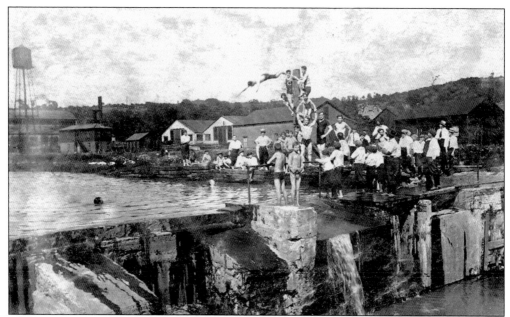

Before the Elliott Company was created, the Fort Pitt Glass Factory and the Clifford-Capell Fan Company occupied the site. Bull Run Creek, located behind the property, was dammed to supply water for the factories. This dam reservoir later became a popular swimming hole for both the community and the factory workers.

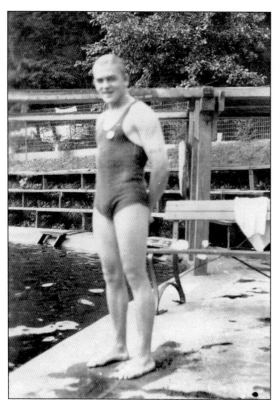

Matt Musick was the winner of the Westmoreland County Diving Contest at Oakford Park on August 6, 1925, with a total of 51 points for 6 dives. The son of V. Musick, proprietor of the Hotel Marian and the Clay Avenue Hotel, Matt became a successful Greensburg sign painter in his later years.

Near the Seventh Street Bridge, the railway built a reservoir for steam engines. In the 1920s, this reservoir became Summerland Beach, a well-known swimming pool. Unfortunately, little information and few photographs of this pool have been found.

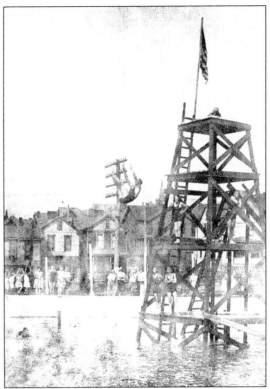

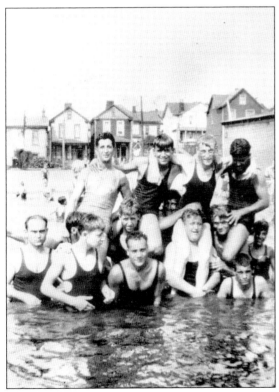

Summerland Beach was a well-used swimming area for many Jeannette residents during the 1920s. Leonard Sementi (front center) of Jeannette is seen here with a group of friends. The houses pictured are located on Railroad Street near the Seventh Street Bridge.

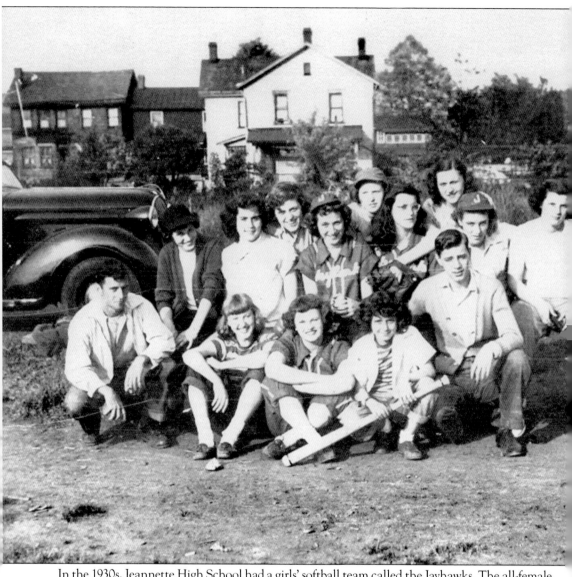

In the 1930s, Jeannette High School had a girls' softball team called the Jayhawks. The all-female team was led by two male managers.

The first baseball game on record in Jeannette took place in 1890, when the Jeannette Grays met a team from Derry, with Jeannette winning the Labor Day contest. Ralph O. "Sox" Seybold was a player on that team. Sox Seybold started his professional baseball career with Easton in 1894. The hard-hitting outfielder advanced to the Philadelphia Americans and, in 1902, hit 16 home runs, a record that endured until 1929, when Babe Ruth swatted 29 for Boston. Even the famed "Home Run" Baker of Philadelphia, home-run king of the American League, never hit more than 12 in a single season.

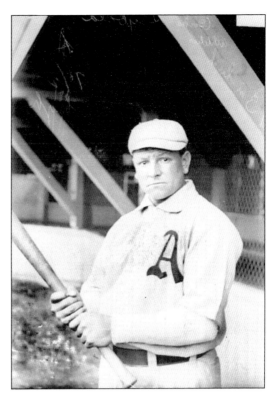

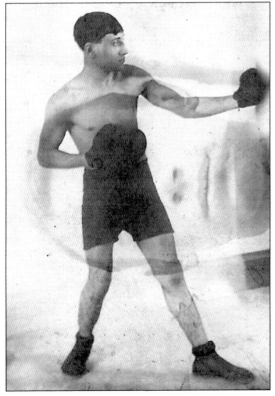

Tony Ross was well known in Jeannette, not only because he tended bar at the Monier Hotel, Manfredo's Bar, and the Colombe Hotel, but also because he was a popular boxer.

In the early days of the city, pugilistic action abounded. George Ooly Yurt, who later became police chief of Jeannette, was one of the early fighters of note. His ring career began in 1895. Yurt fought a much-discussed and illegal bare-knuckles battle against Dave Elliott of New Jersey in a shed near the present site of the Elliott Company. Another rugged battler of the early days was Billy Manfredo, who achieved a solid reputation in the middleweight division, taking on many highly rated opponents.

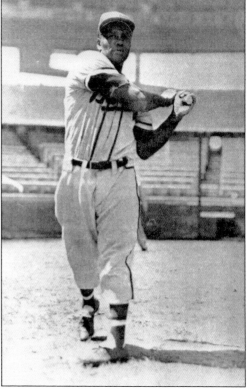

James Buster Clarkson had a long and varied experience in professional baseball. He played in Cuba and Mexico; suited up for the Philadelphia Stars in the Negro National League; played and managed for Santurce in the Puerto Rican League; and was a standout performer at shortstop and third base for the Milwaukee Brewers in the American Association. Clarkson could only advance so far, however, since the color line in the big leagues was not broken until Jackie Robinson joined the Brooklyn Dodgers in 1947.

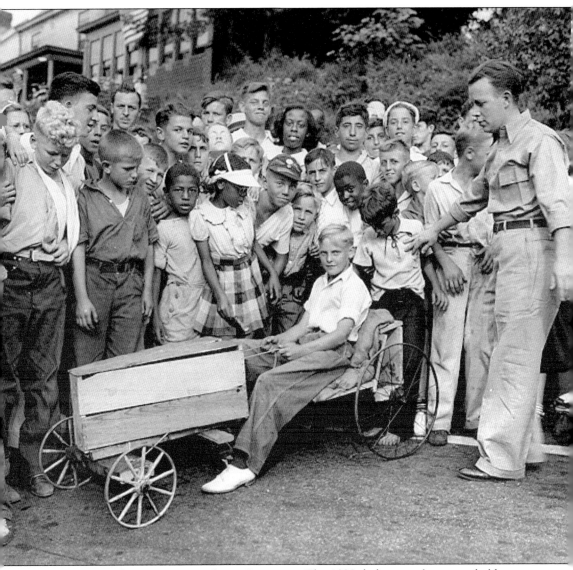

The Soap Box Derby was very popular in Jeannette. The 1938 derby, seen here, was held on North Third Street. It was later moved to Magee Avenue and continued for many years. The faces of these children show their enthusiasm for the sport.

Mike Getto inspired Jeannette to adopt the Jayhawk as mascot. Getto, a Kansas University assistant football coach from 1929 to 1939, grew up in Jeannette. He was also the town's only All-American football player, a distinction he earned while playing at the University of Pittsburgh in 1928.

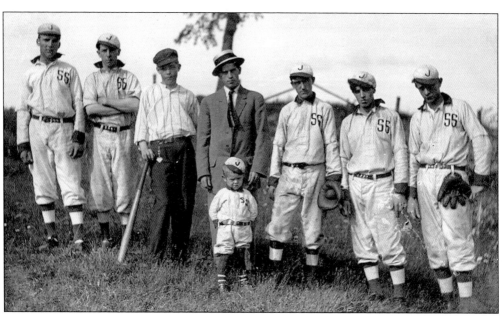

Sports have always been a No. 1 priority in Jeannette, as parents pass the enthusiasm on to their children. Here, a little boy sports the Jeannette "J" for Jayhawk.

Six

OAKFORD PARK

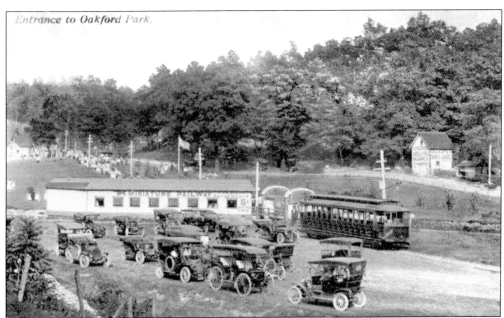

A summer trolley arrives at the entrance to Oakford Park in this 1912 postcard view. Oakford Park was created as a trolley park by the Greensburg, Jeannette, and Pittsburgh Electric Railway Company to bolster trolley use during non-peak times. In April 1896, 43 acres of land was purchased from W. F. Sadler, a major stockholder in the railway company, and Oakford Park began its 93-year history.

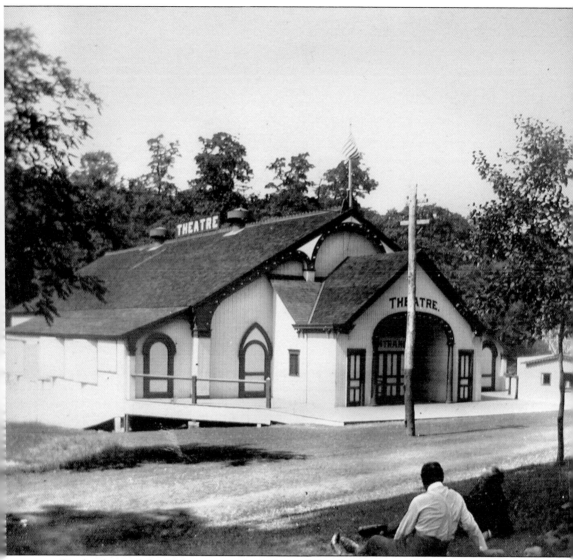

By the dawn of the 20th century, the Industrial Revolution was in full swing, and the working people of western Pennsylvania were eager for the entertainment and relaxation that Oakford Park provided. The Oakford Theatre boasted a seating capacity of 900 and, by 1910, had expanded to 1,800 seats. Vaudeville acts, opera singers, poets, and thespian companies came to the theater. On weekends, the most popular bands of the era performed concerts there.

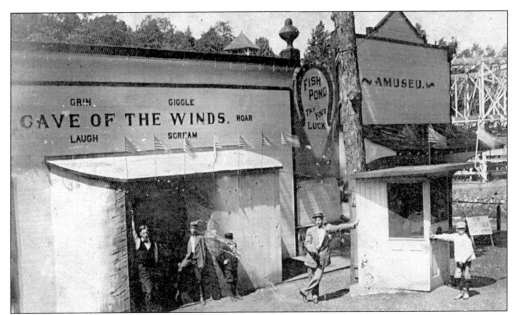

Charles Altman and a Mr. Smeltzer ran these amusements at Oakford Park, along with the roller skating rink. The popularity of the park kept business profitable and encouraged additions and improvements to the facility. Altman is inside the ticket booth at right.

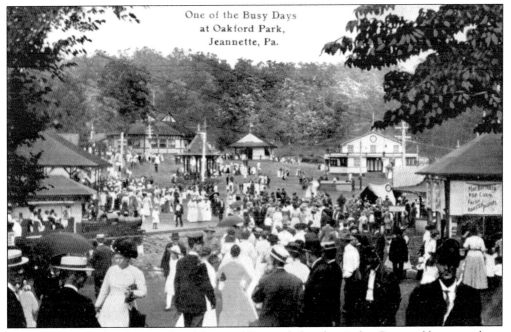

Each year, Oakford Park opened on Memorial Day and closed on Labor Day, and between those two dates was filled with daily picnics sponsored by churches, schools, businesses, and all manner of organizations. Oakford Park in the early 1900s was one of the best and busiest parks in western Pennsylvania. Visitors would descend from the trolley and pass through the open station to the brown bark road with white-washed bricks laid at angles on each side. This postcard picture shows the first view a patron would see upon entering the park.

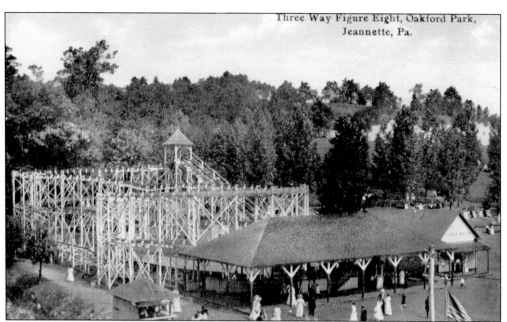

Oakford Park had two roller coasters in its history. The first was destroyed in the Oakford Park flood on July 5, 1903. The second, seen here, was built in 1904. Its original name was the Leap Frog, and later it was renamed the Three Way Figure Eight. By today's standards, it was a very calm ride, but to park patrons at the beginning of the 20th century, it was awesome.

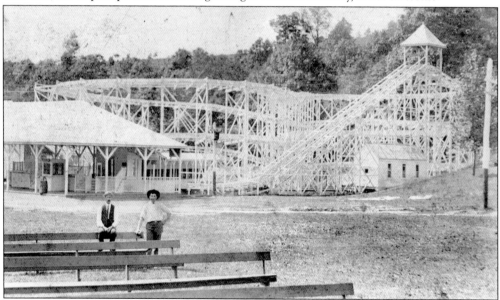

A contest to name the 10 coaster cars was held in July 1904. A $5 gold piece was awarded to each winner. The names selected and the winners of prizes were the following: "Teddy" (after Pres. Theodore Roosevelt), by A. S. Miller of Greensburg; "Parker," by George Gregg of Greensburg; "Arrow," by C. A. Light of Greensburg; "Comet," by Robert Cribbs of Greensburg; "Speed," by Lillian Wolff of Greensburg; "Aerial," by James E. Moore of Greensburg; "Meteor," by J. H. Geary of New Florence; "Diana," by C. B. Layton of Greensburg; "Sylvan," by Louise P. Stephenson of Greensburg; and "Eagle," by May Brown of Greensburg.

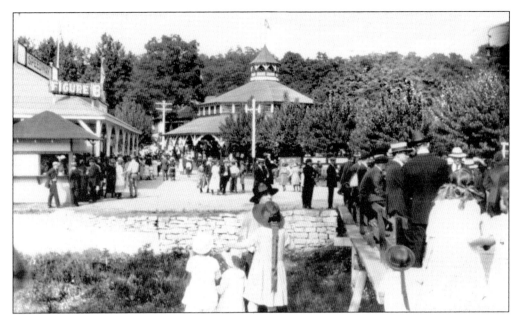

After crossing over the bridge and entering the park, visitors would first see the Three Way Figure Eight roller coaster and the speedway building. Looking past these and following the rows of trees, the carousel building would be in full view. The park landscaping was beautiful.

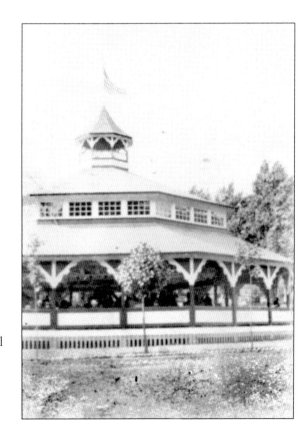

Photographs of Oakford Park's carousel building are the most difficult to find. There were as many as four carousels over the years. This one, the most elaborate, was made by the Philadelphia Toboggan Company.

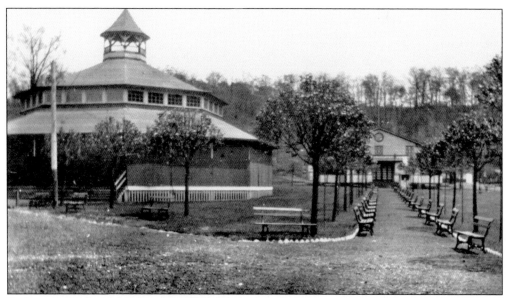

Early spring, before Memorial Day, finds the carousel building covered with canvas to protect it from the elements. This photograph gives an idea of the beauty of the park. In the distance is the Oakford Park Dance Hall, which was the largest in Westmoreland County. The walkways were bordered with white bricks and were lined with benches.

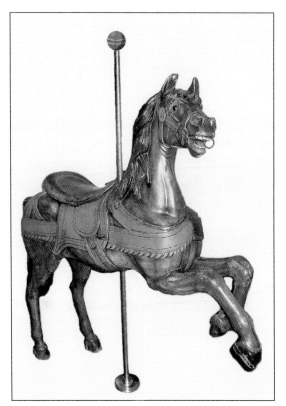

A surviving carousel horse from Oakford Park is owned by Catherine Dvorsky. The horse is meticulously hand carved and painted, a beautiful example of master craftsmanship.

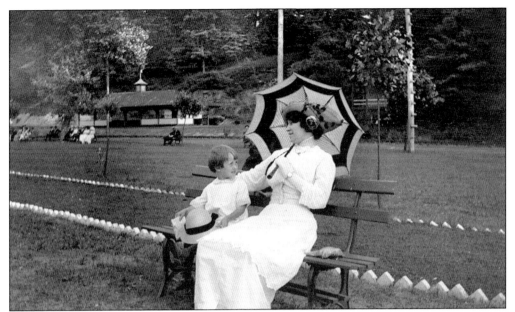

Mrs. Alice Hartung and her daughter enjoy a day at Oakford Park so very many years ago. The Victorian clothing and parasol were proper attire at Oakford Park. Men in suits, children in their finest clothes, and women wearing the fashion of the day were commonplace there. The beautiful lawn, white brick–lined paths, and well-kept buildings were standards at Oakford Park.

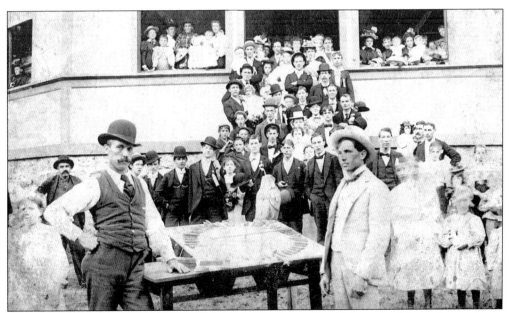

One of the first buildings constructed at Oakford Park was the old dance hall. It was located next to the Ladies Cottage, and before the Oakford Park flood, next to Lake Placid. In the foreground of the photograph, in the white suit, is Victor Howard, the grandfather of John Howard, who founded the Jeannette Area Historical Society.

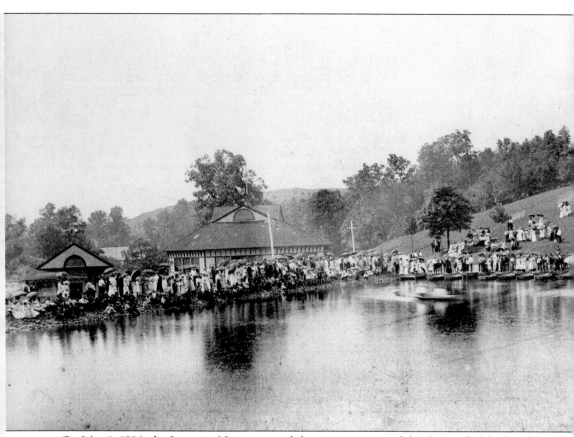

On May 1, 1896, the *Jeannette News* reported that construction of the dam at Oakford Park had been started on Tuesday, April 28. Brush Creek was dammed, and the lake, which would cover five to six acres, began to form. The "puddled earth" method was used in the building of the dam. This process employed a tempered paste of wet clay and sand that acted as water proofing when dry. The dam was built in layers by the Pittsburg, McKeesport, and Greensburg Street

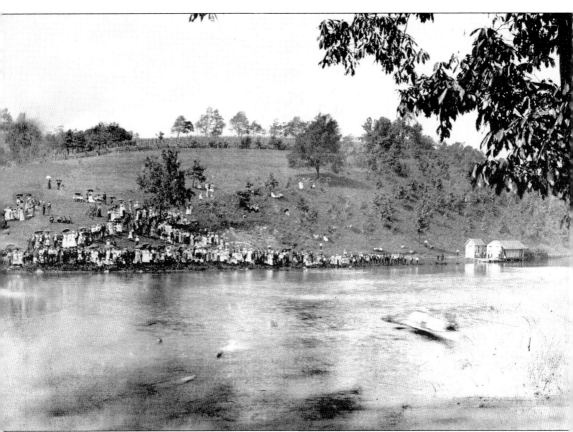

Railway Company. The lake was soon completed and named Lake Placid. For approximately seven years, it was the focal point of Oakford Park. An eating pavilion that accommodated several hundred people was built adjacent to the lake. Couples and families spent hours rowing, drifting, and relaxing on the calm water. Toy boat races were held during the summer, and in winter, skaters took to the ice.

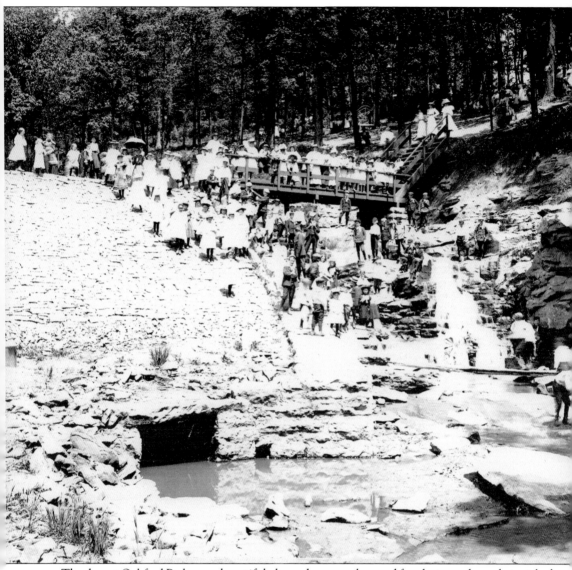

The dam at Oakford Park was a beautiful place where people posed for photographs and picnicked. The dam was reached by using a wooden walkway and steps to a bridge that took visitors to their destination. Once at the dam, children and adults alike climbed up and down the breastwork, enjoying the beauty of Oakford Park and Lake Placid. However, all recreational activity at the park came to an end on Sunday, July 5, 1903, at 8 o'clock in the evening, as the dam broke and flooding ensued.

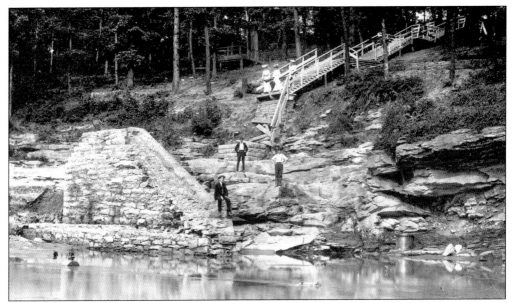

After the dam broke on July 5, 1903, and time had passed, the remains of the dam continued as an attraction. People followed the walkways and went to the location of the dam to see the destruction.

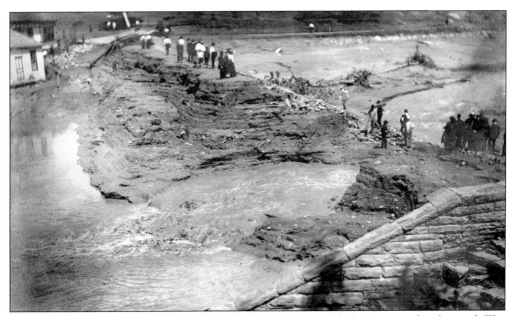

From this viewpoint, the destroyed dam and the vast, empty lake bottom can be observed. The broken dam enables the layers of earth, sand, and stones to be seen. The "puddled earth" method of construction is also more visible from this vantage point.

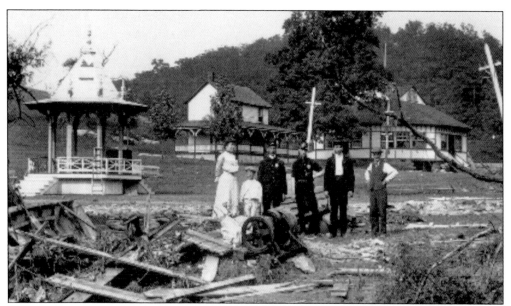

The destruction to Oakford Park was devastating. The gazebo located in the center of the park was barely saved from the flood waters. The six people in the photograph are assessing the damages.

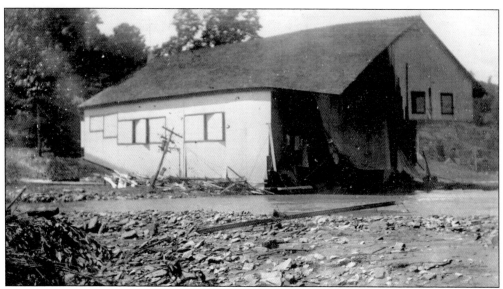

The Oakford Theatre was located at the entrance to the park. The swift-moving flood waters followed a path behind the theater, destroying part of the building. This shows the damage done to the rear of the theater.

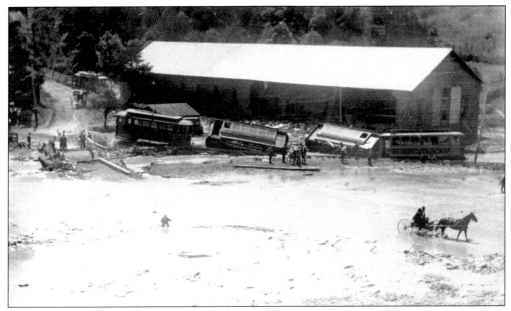

At the intersection of Route 130 and Oakford Park Road stood the trolley barn at the entrance to the park. Part of this building was destroyed, along with several trolleys, as the flood waters raced toward Jeannette. Here, a horse and rig makes its way through the waters.

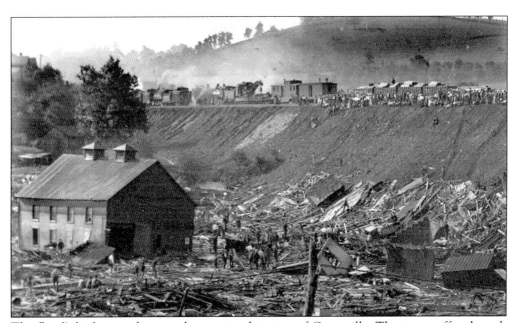

The flood's high-water line can be seen in this view of Grapeville. The town suffered much damage, as evidenced by the piled debris.

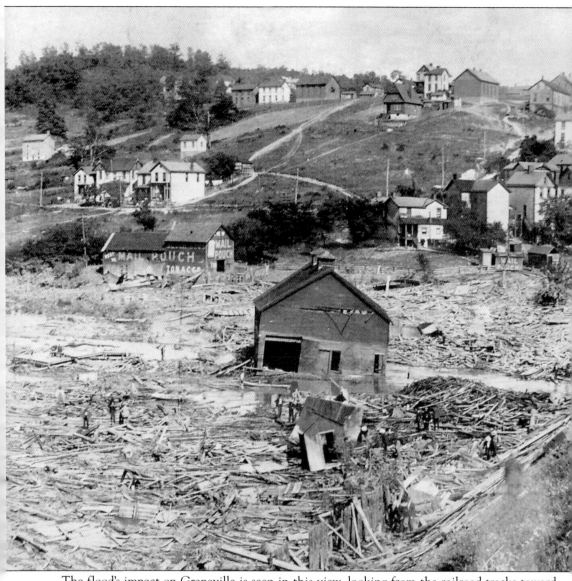

The flood's impact on Grapeville is seen in this view, looking from the railroad tracks toward Brown Avenue and Kerr Street. The destruction was overwhelming.

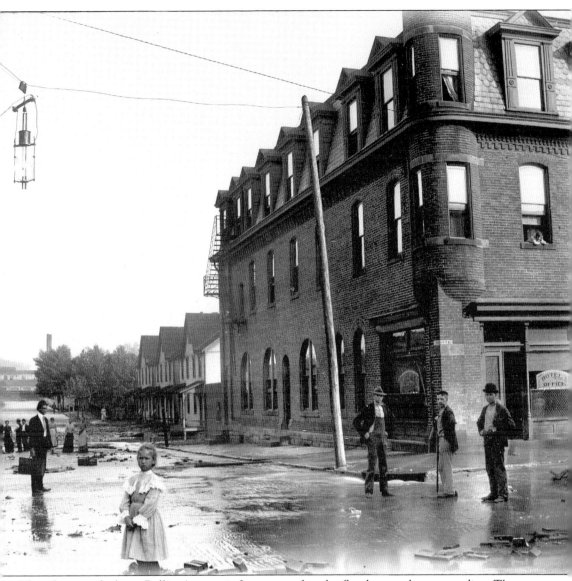

This photograph shows Bullitt Avenue in Jeannette after the flood waters began receding. The Colombe Hotel incurred damages to its first floor and basement. Here, a little girl has ventured out to see the waters. Other people have chosen to assess the situation from a drier vantage point, as they look on from the windows of the Colombe Hotel, at right.

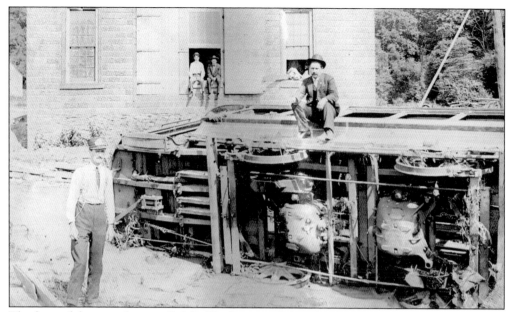

The force of the water leaving Oakford Park is revealed in the damage done to a trolley car. The 28-ton car was overturned as the swift flood waters sped toward Jeannette.

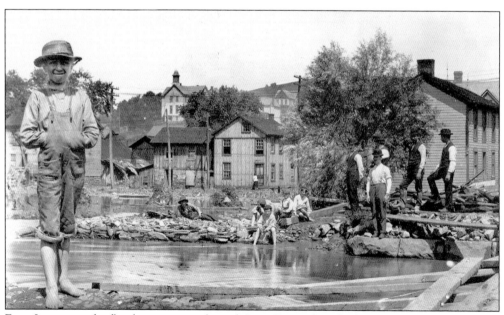

From Jeannette, the flood waters went through Penn Borough. A little barefoot boy standing by a bridge in Penn inspects the damage. The path of devastation began at Oakford Park and proceeded through Grapeville, Jeannette, Penn Borough, Manor, and into Irwin before subsiding.

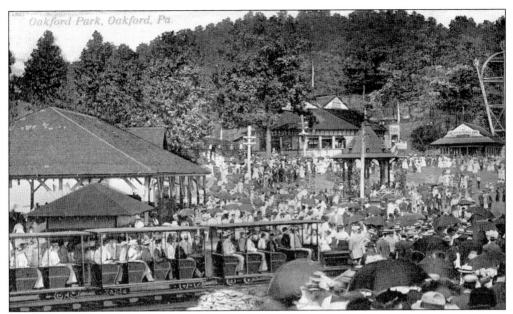

Oakford Park was rebuilt better than ever. The flood of 1903 was in the past and Oakford thrived in the present. New buildings were erected, old buildings were repaired, and people returned to see the wonders of Oakford Park. A miniature train, the new Oakford Inn, and the familiar gazebo welcomed visitors.

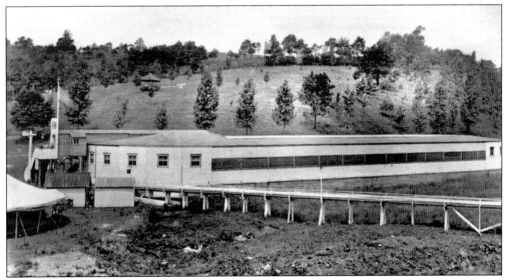

The roller rink at Oakford Park was, to say the least, huge. It was operated by Charles Altman of Jeannette. The building could be accessed through the park and also by a walkway from Oakford Park Road. The rink was a long, oval building that surrounded an open courtyard, and was constructed on land once covered by Lake Placid.

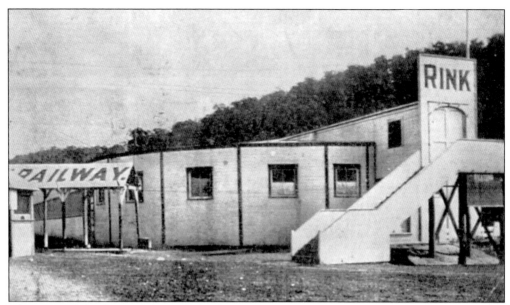

This view of the front of the roller rink shows its unique construction. The building could be entered at ground level or on the second level from the walkway. Next to the rink was the miniature railroad. The tunnel for the miniature railway, as seen in postcards, was alongside the roller rink and was also used to garage the train when it was not in use.

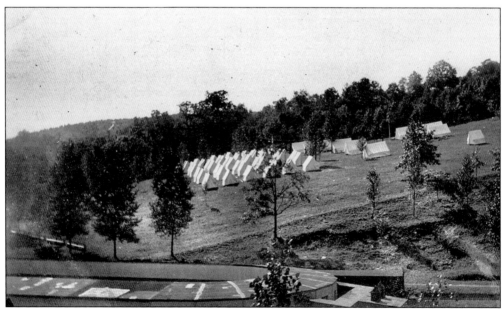

The hill above the roller rink, which in the past had bordered Lake Placid, was used by the military to prepare soldiers for World War I. The soldiers camped out in tents on the hill and did their training on the beautiful land surrounding the park.

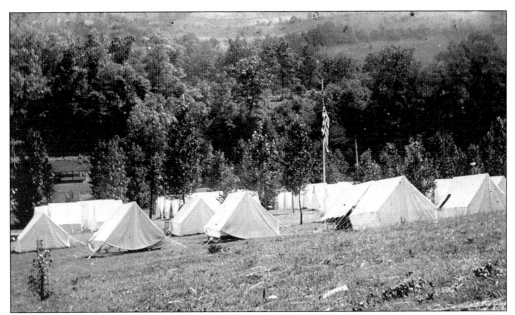

Looking from the top of the hill toward the park, this view shows the soldiers' tents at Oakford Park. The use of the park by the military was of great importance in the training of soldiers.

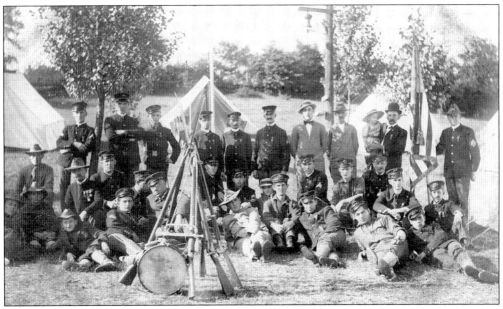

Soldiers pose for a group photograph at Oakford Park. Before World War I, the military took advantage of the park grounds. Military maneuvers were a common sight there and drew large crowds of spectators.

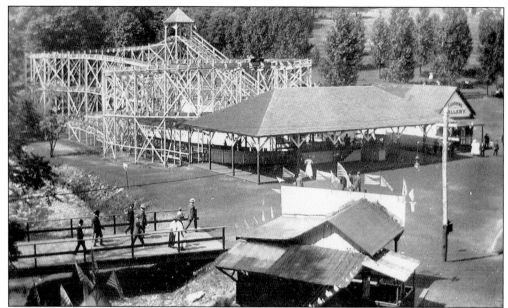

The Three Way Figure Eight roller coaster, a main attraction at Oakford Park, can be seen in this 1910 view, along with the Laughing Gallery. By today's standards, the roller coaster was relatively tame, but close to 100 years ago, it was both thrilling and breathtaking.

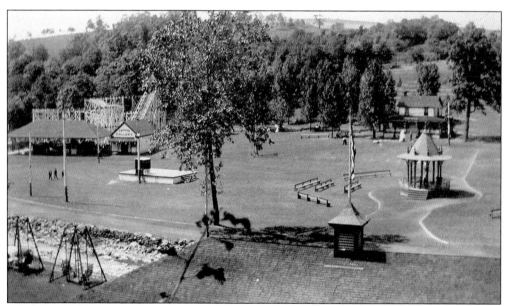

This 1910 photograph provides a broad view of Oakford Park. On the left are the Three Way Figure Eight roller coaster (in background) and the Laughing Gallery beside it; on the right are the Ladies Cottage (in background), the gazebo (in middle), and a pavilion roof (in foreground). Oakford Park was one of the most beautiful in western Pennsylvania. Its location, along with its manicured lawns and gentle hills, provided relaxation and diversion from the daily grind of life at the beginning of the 20th century.

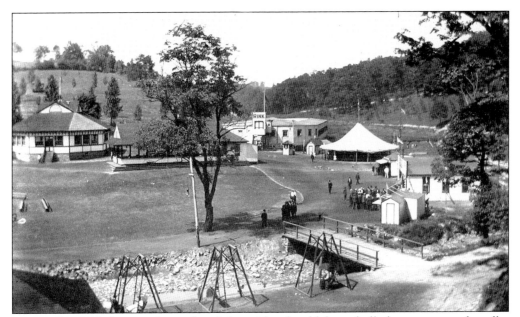

Seen in this 1910 photograph are, from left to right, the old dance hall, the restaurant, the roller rink, the tent that held the second carousel, one of the bridges, and the swings. Compared to amusement parks of today, Oakford Park seems comparatively simple, but to the patrons at the beginning of the 20th century, it was a magical place.

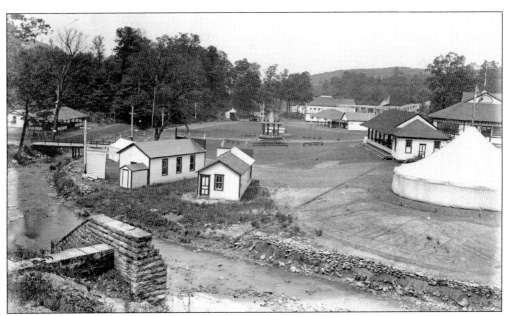

This 1910 view from the back of the park shows the remains of the dam, Brush Creek, and most of the park. By 1910, all the damage caused by the 1903 flood had been repaired. The old lake bottom now held the roller rink and the miniature railway.

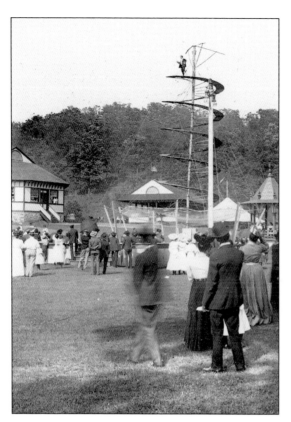

This outside matinee at Oakford Park included a man at the top of a spiral ramp; underneath him was a safety net. It is hard to visualize what he is doing, but the crowd seems to be enjoying the performance. The spectators are wearing their finest clothing for their day at the park.

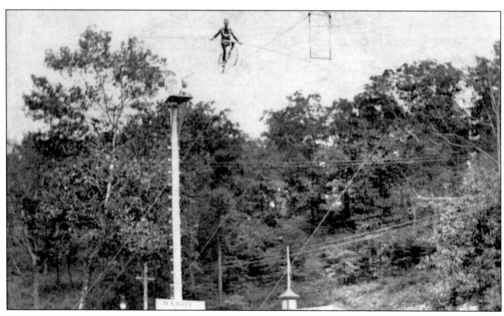

A tightrope was strung high above Oakford Park for this high-wire act. Upon close inspection, a trapeze is visible. The park supplied many fascinating acts for its visitors on the wide expanse of lawns.

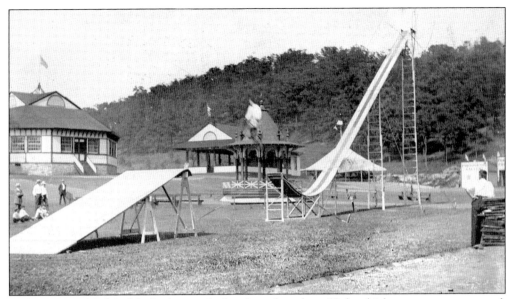

In the center of Oakford Park, close to the bandstand gazebo, a 30-foot-high ramp was constructed; in front of the ramp was open space, and beyond it, another ramp to ground level. The bicycle rider is caught by the camera in mid-air during a jump. The lack of spectators seems to place this event during a rehearsal.

Henry St. Peter was the caretaker and head of security at Oakford Park. Here, he stands beside a horse-drawn sleigh in front of the Ladies Cottage in 1906. The sign bears a flag covering the word "Ladies," as the cottage served as a residence for the St. Peter family when the park closed for the winter. A Bell Telephone sign on the porch announces the location of the telephone at Oakford Park.

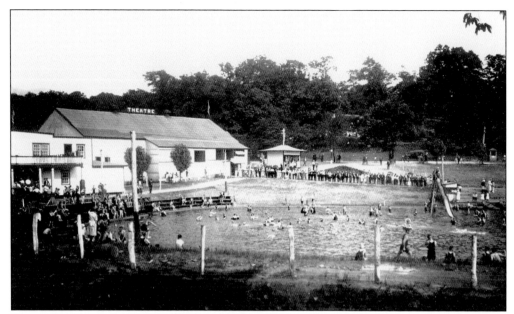

The swimming pool at Oakford Park was built in 1922, and at the time, was the first and largest pool at any amusement park in the country. This 1923 photograph shows the location of the Oakford Theatre in relation to the pool. The theater was torn down in 1924. The old wooden fence around the pool is visible, along with the original bathhouse.

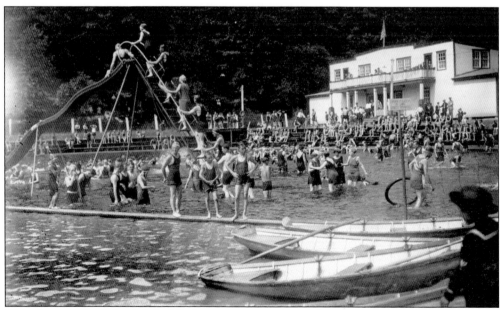

This photograph of the Oakford Park swimming pool was taken in the 1920s. At the time, the pool was divided into two sections—one for swimming and one for rowboats. The swimsuits of the period are a lot different from the suits to come.

Seven

POLICE AND FIRE

The 1905 letter to the borough council of Jeannette from the police department requests a pay raise from $1.80 to $2 a shift. The 1907 letter shows that the policemen received the raise of $2, but were not given any other raises. Policemen were paid for every day of the month, including weekends.

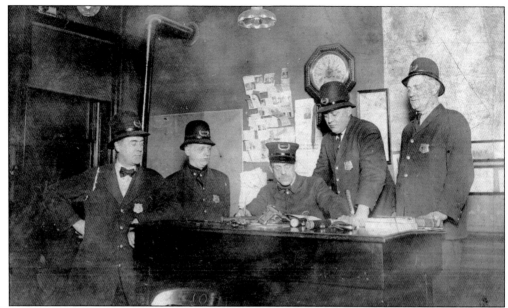

A 1914 view of the police chief's office shows both gas and electric lighting; mug shots and reward posters on the wall behind the desk; and old guns, flashlights, a billy club, and a knife on top of the desk. The policemen in the photograph are, from left to right, T. Cowan, H. Carey, V. Shaffer (seated), V. Bussard, and future police chief George Ooly Yurt.

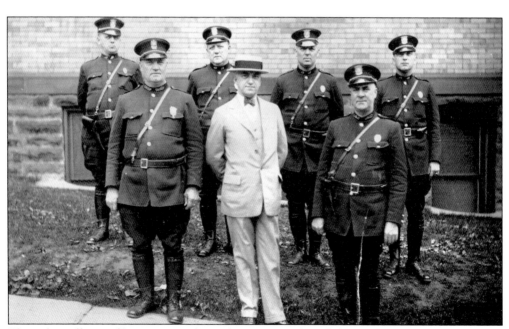

The police officers of Jeannette in the mid-1920s were, from left to right, as follows: (first row) Chief George Yurt, burgess Elias Katz, and Thomas Cowan; (second row) Carey brothers William and Harry, William Peel, and Henry Pfiel.

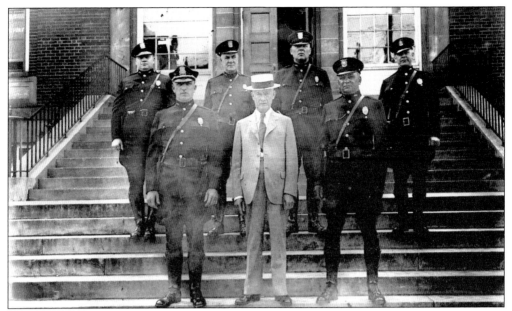

Standing on the front steps of the municipal building, these police officers of the 1930s are, from left to right, as follows: (first row) Charles Walters, Chief Harry Leyh, and burgess Louis Alsopiedy; (second row) Francis Cramwe, Thomas Cowan, William Peel, and Louis Hartle.

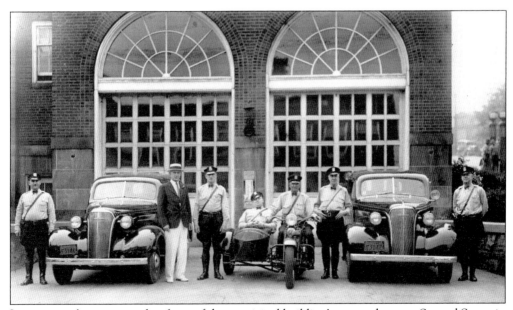

Jeannette policemen stand in front of the municipal building's garage doors on Second Street in 1937. The municipal building is located on the spot where the Marian Hotel once stood.

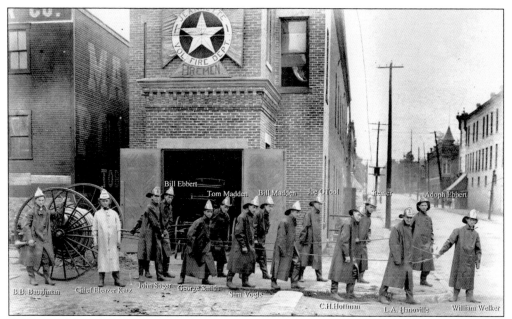

Jeannette's Hose Company No. 1 Volunteer Fire Department, on the corner of Magee Avenue and Fifth Street, is seen here before 1915. The station is located across the street from Turner Hall. A horse-drawn wagon sits inside the building, and outside, firemen pull the hose cart. The fireman at the far left holds a horn.

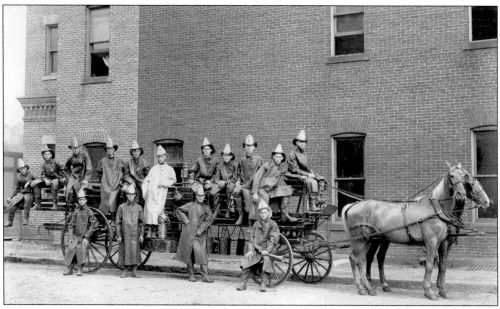

Taken on the same day as the previous image, this photograph shows a horse-drawn ladder wagon at Hose Company No. 1.

Hose Company No. 3, on North Seventh Street, was one of the three volunteer fire stations in pre-1915 Jeannette. From the building's tower, firemen could watch for blazes throughout the city. To the right of the firehouse is the tower of the old Gaskill School. Use of hose companies ended in 1915, when paid fire companies took over.

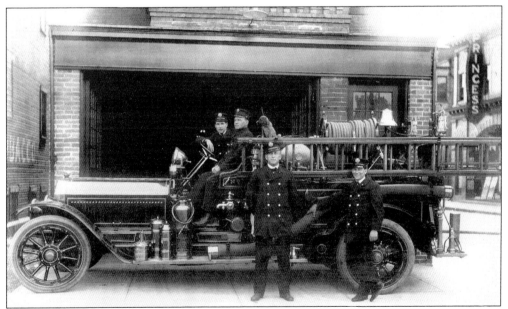

Paul C. Schlingman was the first paid fire chief of Jeannette. Here, he sits in the front passenger seat of the right-hand-drive fire truck at Hose Company No. 1 on Magee Avenue. The truck's top speed was 60 miles per hour. It had a 120-horsepower-capacity pump, and used 750 gallons of water at 120 pounds pressure, with 300 feet of hose. The nozzle tips were one and a quarter inches in diameter.

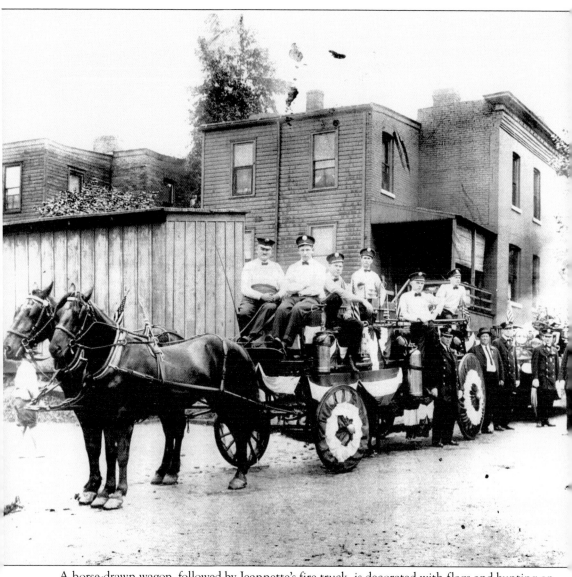

A horse-drawn wagon, followed by Jeannette's fire truck, is decorated with flags and bunting on Bullitt Avenue for a parade. The photograph dates from before 1920. Fire chief Paul C. Schlingman stands at the far right.

Eight

LIFE IN JEANNETTE

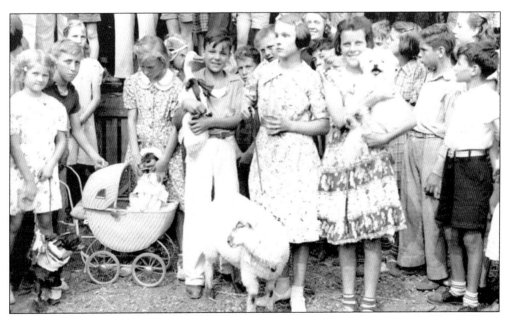

The Mutt and Pet Show of 1938 included dogs, geese, sheep, and other animals. The children were completely involved in the show, as shown in the expressions on their faces.

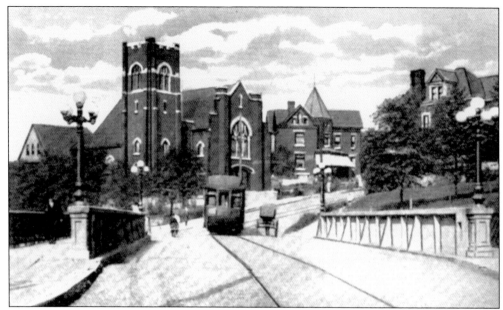

Organized in Jeannette on April 13, 1890, the Holy Trinity Lutheran Church is located at the corner of Gaskill and North Third Streets. The original church building was razed in 1917, and the current structure, pictured here, was erected in its place.

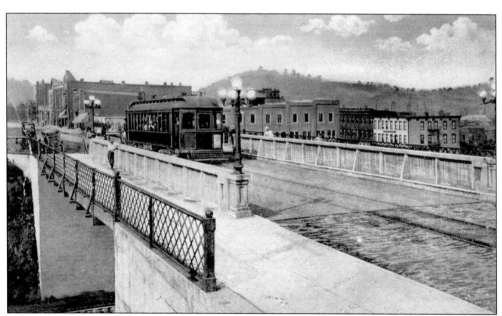

One of the most beautiful bridges in Jeannette was the Second Street Bridge, with its wrought-iron railings and light fixtures. Looking toward Jeannette from the bridge, this view shows the Windsor Hotel on the right and the McKee Hotel at the end of Second Street.

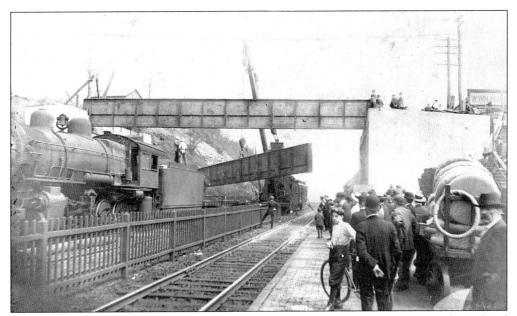

In May 1913, the old wooden Second Street Bridge was replaced with a structure of metal and cement. The wooden bridge had been found unsafe in 1909, and streetcars weighing 28 tons could no longer cross it. Trolleys would stop on one side of the bridge; the passengers would unload and walk across to another trolley waiting on the other side to continue their journey.

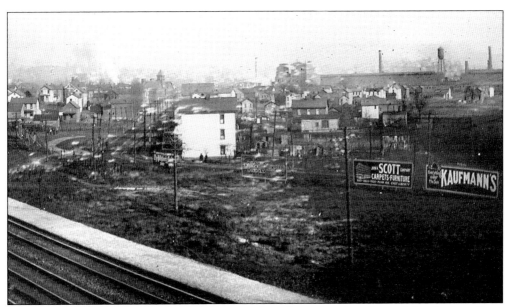

When taking this view, the photographer stood on the railroad tracks with his back to Penn and looked toward West Jeannette and Bakers Corner. The billboards seen were for the benefit of train passengers. Further up Penn Avenue is West Jeannette; the glass factory is on the right and the brewery is the tall building in the distance.

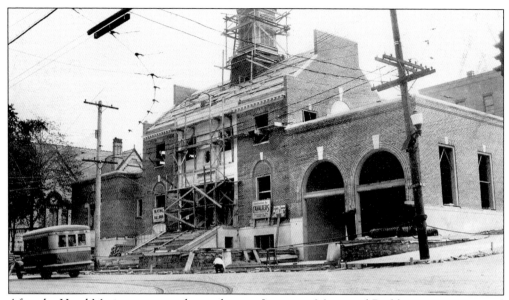

After the Hotel Marian was torn down, the new Jeannette Municipal Building was constructed on the site in 1927. The city offices were then moved from Magee Avenue and Fifth Street to the new building on Second Street.

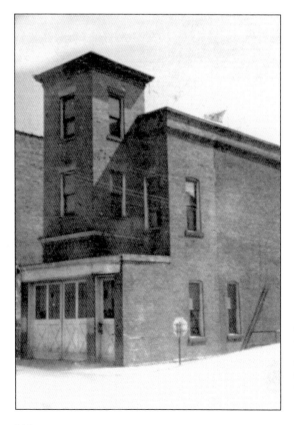

The old city hall at Magee Avenue and Fifth Street, across from Turner Hall, contained the police station, Hose Company No. 1, and borough offices. The fire tower on the building marked the fire station.

This ivy-covered wall is at the back of the Colombe Hotel. The outdoor swimming pool used to be located at the base of the wall.

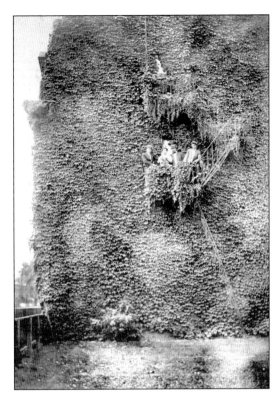

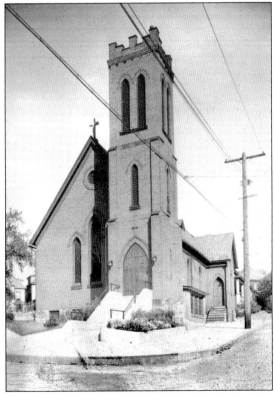

The Episcopal Church of the Advent was organized in Jeannette in 1890, under the name of St. Stephen's Mission, by Rt. Rev. Cortland Whitehead, bishop of Pittsburgh; Rev. George Van Waters, rector of Christ Church, Greensburg; and a number of Jeannette's Episcopalian residents. On July 29, 1904, the mission laid the cornerstone for its own building on newly purchased lots at the junction of Clay and Cuyler Avenues and North First Street. The first public services were held on Christmas Day 1904, and the building was dedicated on January 22, 1905.

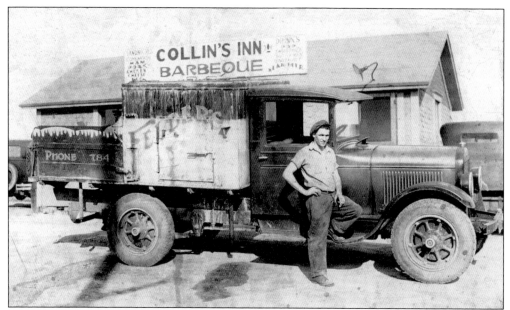

On May 30, 1918, Memorial Day, Sam and Jennie Felder opened their business at 221 South Fourth Street—the former location of Shuster and Gormley Wholesale Grocers—where the couple sold homemade candy and ice cream. In 1925, the Felders started a food service and continued selling their ice cream. The slogan for Sam Felder's Ice Cream was "Eat more of it, because it's pure." Carl Schmidt, who delivered ice cream for Felder's, stands here with the truck.

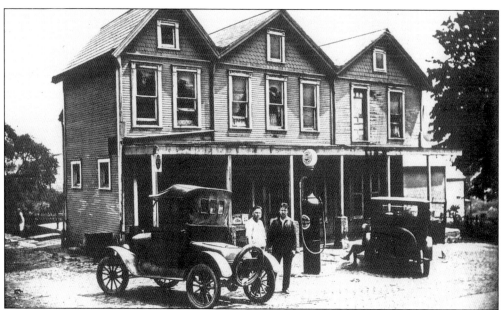

The Fisher Hotel, located on Harrison Avenue, originally stood in Penn Township, until the area was annexed by Jeannette in the early 1920s. The family-operated hotel also had a gas station and small store.

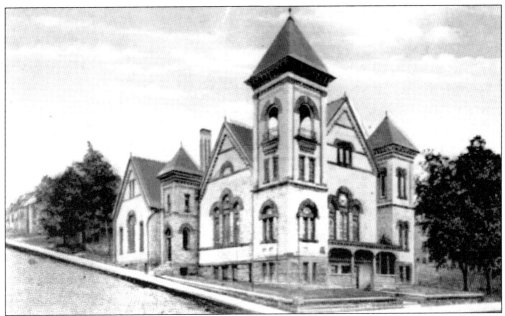

When the First United Methodist Church congregation only included nine members, Rev. Barnet Thomas bought a lot at the corner of Gaskill and North Sixth Street, where, in 1890, a one-story church building was dedicated. By 1897 the poorly located church had become too small for the congregation, so a second lot at the corner of Second Street and Magee Avenue was purchased. The new church, pictured here, was completed there in 1899, and formal dedication was held in 1907.

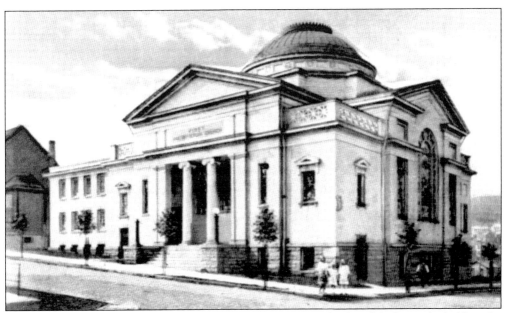

In 1889, Rev. W. B. Carr bought three lots at the corner of Third and Bullitt to be held as the site of the new First Presbyterian Church. The lots secured by Reverend Carr were approved as a church site, and the contract for building was given to H. C. Oakley. Reverend Carr declined a call to become the new church's first pastor, but Rev. Thomas V. Milligan accepted. The new church building was dedicated in 1890.

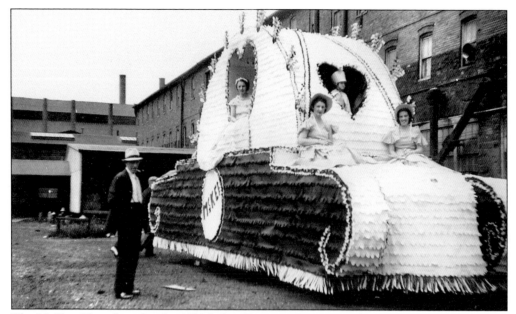

The McKee Glass float for the 1938 Labor Day parade rests in the company lot. Jeannette's Clay Avenue was the ideal location for parades. The long, wide avenue was on a gentle slope that gave a beautiful view.

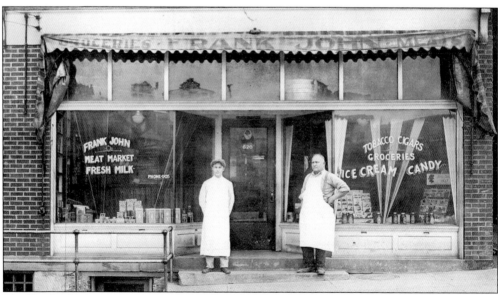

The Frank John Meat Market was located at 620 Lowery Avenue, the present site of Dr. Fetchero's office and across the street from DeNunzio's Restaurant. Frank, right, appears here with his son Aquino. The market sold just about everything, making it comparable to convenience stores of today.

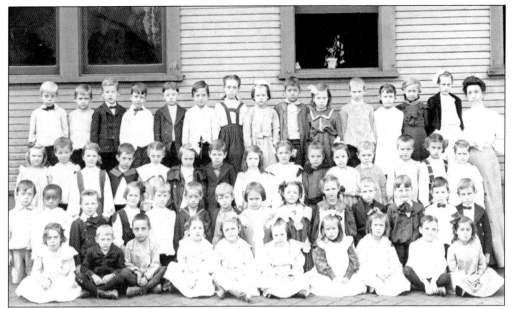

The 1906 first-grade class at the Gaskill Avenue School poses with teacher Lucy Pooley.

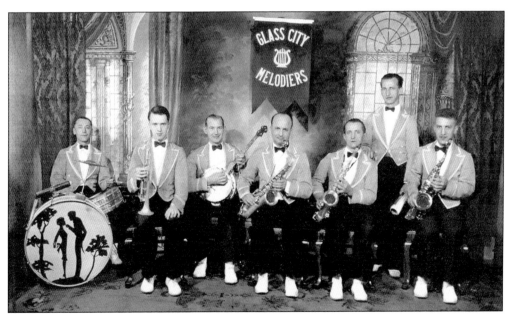

The Glass City Melodiers was a very popular musical group. Shown in this 1935 photograph, the seven members were, from left to right, as follows: (seated) Larry Waites, Sherman Chew, Wes Griner, Charles Kasparek, George Kasparek, and Emil Kasparek; (standing) August Kasparek.

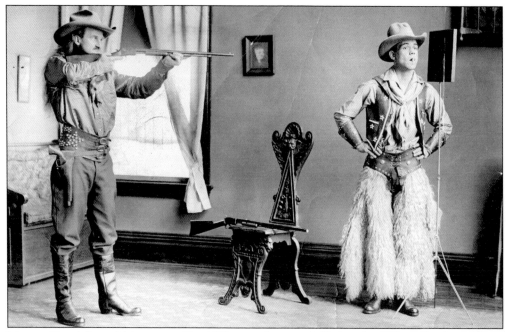

Murray Guy, left, and his stepson Ray Wilson, right, were billed as the Wilson Brothers, Fancy and Daredevil Rifle Shooting. After Ray's death in 1925, Murray traveled with many Wild West shows, including Pawnee Bill's Wild West Show. Murray spent his last years at his Jeannette home and died in his 90s.

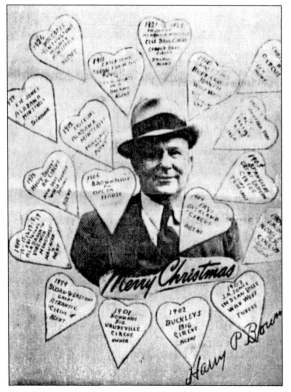

Harry P. Bowman of Jeannette owned a traveling circus, and also went on tour with other circuses. This Christmas card features Bowman's image surrounded by hearts that are inscribed with the names of places he had visited.

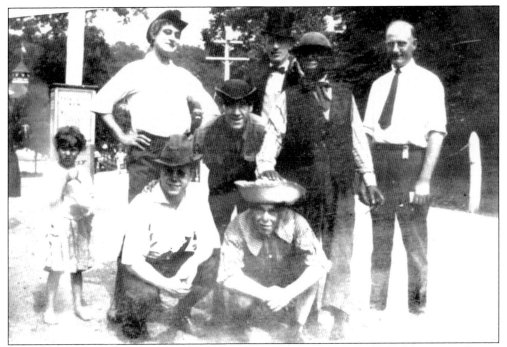

Brothers Shemp and Moe Howard appear at Oakford Park in 1921 with the Marguerite Bryant Players. The Howards lived in Jeannette during their bookings at the Oakford Park Theater. In this photograph, Shemp is bending over in the middle, and Moe is in front, wearing the straw hat. The brothers later became members of the Three Stooges.

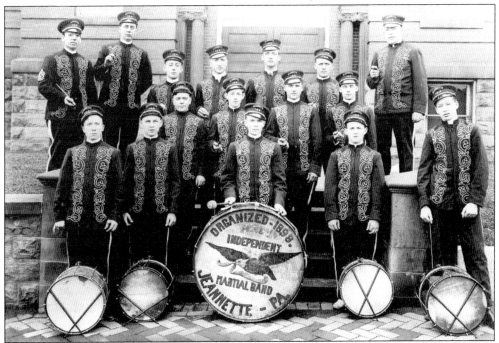

An early Jeannette musical group, the Independent Martial Band, formerly the C. H. Stevens Band, is assembled in front of Fourth Street School in 1911.

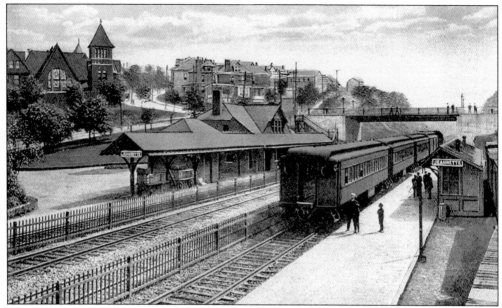

The Jeannette train station was one of the most beautiful and busiest stations in Westmoreland County. Buff brick covered the walking areas around the well-kept and state-of-the-art station.

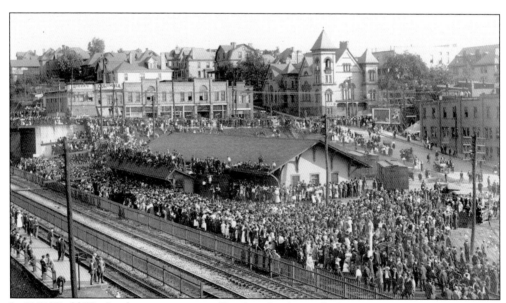

In 1917, World War I inductees were sent off by their families at the Jeannette station. This happened again during World War II. The view looks toward Second Street and Magee Avenue.

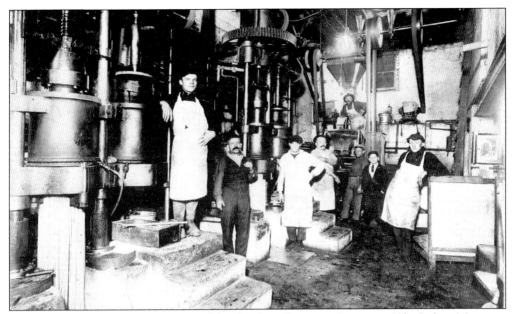

La Famosa macaroni was a popular and familiar brand name in Jeannette. The Italian Macaroni Factory, at 505 South Fourth Street, started production on Saturday, November 16, 1917, with Antonio Ossaio as president, E. Gusperti as vice-president, E. Bertoni as secretary, and Charles Ewalt as treasurer. The plant's production capacity was 500 twenty-pound boxes a day.

Three boys sit on the front steps of 127 North Second Street, the home of early Jeannette photographer James Billups.

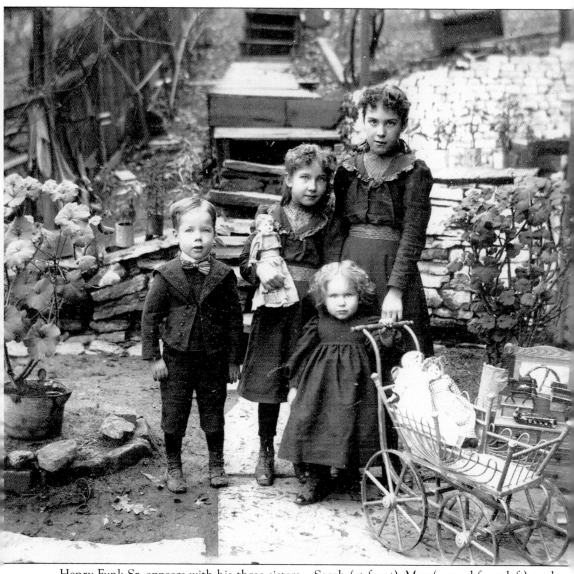

Henry Funk Sr. appears with his three sisters—Sarah (at front), Mae (second from left), and Mary—at the Bowman home on Schrader Street about 1893. Some years later, Mae married Walter Matthews, Mary wed James Hayes, and Sarah married Dan Frey.

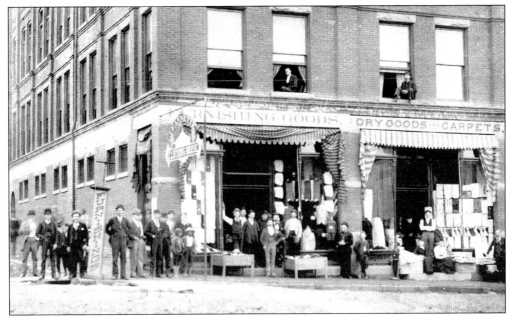

The Jeannette Clothing House, located at the corner of Clay Avenue and South Fifth Street, is pictured here, before it was destroyed by fire on January 31, 1892. Robert M. Baughman, a local merchant, stands near center, leaning with his hand on the door jamb. Gillespie's would eventually take over the building.

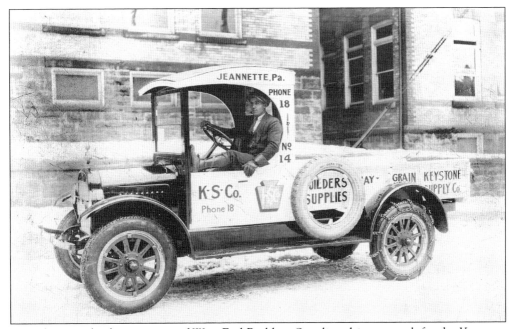

Joe Salvatore, the future owner of West End Building Supplies, drives a truck for the Keystone Supply Company in 1925. This photograph was taken at the side of the Clay Avenue School, facing Second Street.

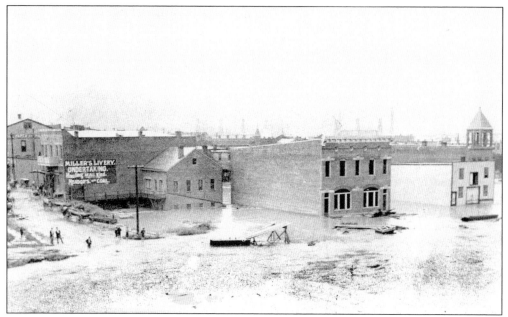

This flood image from the late 1890s gives a view of several buildings damaged by the waters. The sign on the building to the left reads, "Miller's Livery. Undertaking. Hauling of all Kind. Headquarters for Coal," advertising the diverse businesses within. To the far right is Hose Company No. 1 with the fire tower. City hall is also in the same building, along with the jail.

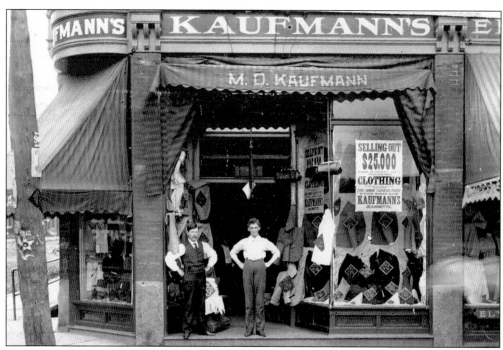

At the corner of Clay Avenue and Fifth Street, the M. D. Kauffman Store sells out its merchandise. This mid-1890s photograph shows merchant M. Baughman on the right, in the white shirt. (The man in the vest is unidentified.) This building later became the home of Gillespie's.

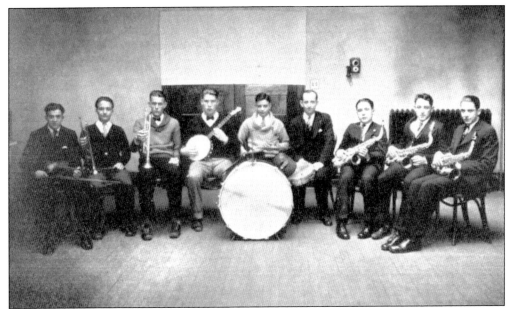

Vaughn Monroe, one of Jeannette High School's most famous graduates, was a member of the class of 1929. In this picture taken during his junior year, in 1928, Monroe sits with fellow members of the jazz band. He is third from the left, holding a trumpet.

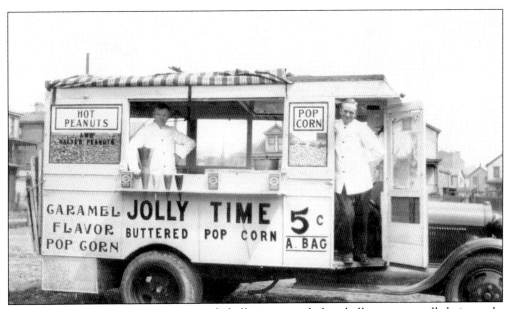

George Lunn, left, and Joe Lunn attended all events, including ball games, to sell their goods. In this late-1920s photograph taken in West Jeannette, their Jolly Time truck offers buttered popcorn, hot peanuts, and caramel corn for 5¢ a bag.

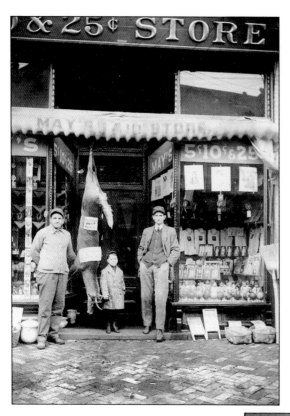

John Byers (left) and J. E. May (right) are seen in front of May's 5¢, 10¢, & 25¢ store at 507 Clay Avenue. The youngster in the middle is May's son. This 1915 photograph shows the variety of merchandise that was available there.

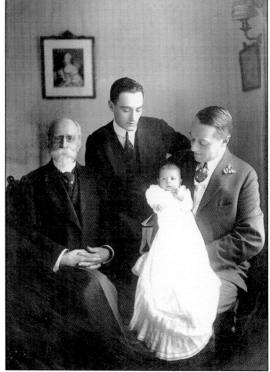

This 1918 photograph of male members of the H. Sellers McKee family shows, from left to right, H. Sellers; his grandson, also named H. Sellers; his great-grandson, baby Julien; and son Thomas.